India of One Thousand and One Nights

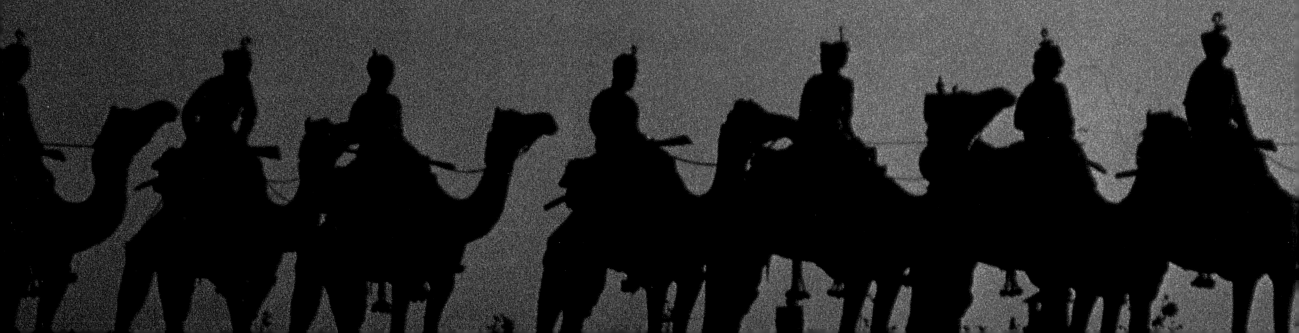

INDIA
of One

Thousand and One Nights

Roland and Sabrina Michaud

A New York Graphic Society Book
Little, Brown and Company • Boston

To all those in India who helped us live our thousand and one nights.

*I*ndia is woman. She is mother, goddess, and adored as one. She is shakti, energy, source of all things. Eternally. The embrace uniting Parvati and Shiva lasts through millions of years. Lakshmi, wife of Vishnu, is the goddess of beauty and fortune; she is called the Millionairess. And the god Brahma's mate, Sarasvati, is the goddess of speech, eloquence, knowledge, patroness of art and music, mother of poetry, the archetype of Scheherazade.

India is women. Servant or princess, rich or poor, one spirit moves in all of India's women. The same femininity inspires the poorest of country women to wear colors as bright, adornment as sophisticated, jewels as heavy as a queen's.

The Indian woman is beautiful. Her sari wraps her in beauty; golden powders, perfumes, and beads add to her allure. Whether svelte as in the cave paintings at Ajanta or voluptuous as in the carvings at Khajuraho, always she will have jet-black hair flowing down a body slathered with incense and sandalwood. Always the immense kohl-ringed eyes lighting a moon of a face.

Everything that is beautiful in India is dedicated to women. When Shah Jahan's favorite wife, Mumtaz Mahal, died, the stricken emperor decided to build her a memorial "as beautiful as she was." The result was the Taj Mahal, an accomplished blend of Moslem and

Hindu styles, the gem of Indian architecture. This work of love delights us with the purity of its proportions and the perfection of its situation. Like every Mogul emperor, Shah Jahan had a garden in his heart. For his beloved, he created in stone a paradise of immortal flowers, so lovely we can almost smell them. The story goes that the craftsmen who encrusted these jade and cornaline, agate and lazulite flowers had reached such a degree of skill that they could cut the stones by sight alone. The quintessence of refinement: the subtle variations in color bathing the marble at different times of day symbolize the changing moods of the feminine mystique. Yet the strangest part of Mumtaz Mahal's charm is not so much her legendary beauty as the mystery surrounding it. Though none of them ever saw her, poets said that when she appeared the stars went out and the moon hid itself in shame. Her beauty transcends her memorial; Mumtaz Mahal is the essence of the Taj, just as Scheherazade, another unseen woman, is the verbal essence of the Thousand and One Nights, the literary masterwork of the oriental world.

"At this point in her story, Scheherazade saw morning coming, and discreetly fell silent. But when the thousandth night came she said . . ."

And if King Shahryar, delighted "to the limits of delight" with the lovely teller's tales, could not resist Scheherazade's eloquence, who else could?

Let us go back twenty years.

In the dimness of our furnished rooms in Paris, the Thousand and One Nights is our bedside book. Each evening we take turns enjoying it. Like the beads of a giant rosary, the tales spread out night after night. We listen closely to the myths and secrets of the universe that fascinate us and come to life in our sleep. We dream of the Orient until the day we decide to measure our dream against reality. We are on our way. Our first eastward journey lasts 1584 days. It takes us from Turkey to China, passing through Samarkand, Tartary, and India along the way.

Dazzled by the beauty of the world, we become photographers to capture glimpses of it. In love with light, we move from the magic of words to that of pictures, and for twenty years, inexhaustibly, we follow our dream with the same passion and a deep well of patience. And yet what a gap there is between imagination and experience: so many contradictions and disappointments, so much frustration. And still the Orient fascinates us, still Scheherazade's tales enchant us.

Although by tradition the Thousand and One Nights are set in an Arab-Persian context, India is the country best suited to intepreting them photographically. India is where we found the most mysterious customs and the most prodigious precious stones, the most sumptuous fabrics and tastiest mangoes, the headiest spices and subtlest dishes, the most amazing architecture, most fragrant flowers, the most moving and acrobatic erotica, the most sophisticated dance and refined music. India is where we found Scheherazade, Ali Baba, Sindbad, and Aladdin. We love India, a land at once single and multiple, realistic and illusory, excessive and contradictory, exploding with life at its most vibrant. India's bazaars, India's fairs, India's pilgrimages, India's crowds where every human archetype mingles: ascetic, ash-coated bodies and huge Buddha-like bellies; doelike or fiery glances and the third eye of Shiva. Crouching in the roadway, an ear cleaner whispers gossip to his client. In his shop, a copperware dealer approaches, hand on his heart, and introduces himself: "After Ali the Prophet's son in law, Ali Baba and the Forty Thieves, Muhammad Ali the boxer, and Ali Aga Khan, I'm the fifth Ali, Ali the poor shopkeeper."

In dark temples where musk and incense burn, priests with plastered hair and water-buffalo eyes dress the statues, for here the gods are alive. A monkey swipes a banana from a fruit seller's stand. A skeletal cow grazes on wastepaper. And here we are trying to slake the aftertaste of some heady pepper, sipping cup after cup of ginger and cardamom tea in the

shade of a banyan tree. Wedding music erupts. Splendidly decked out, an elephant painted with flower designs majestically parts the crowd in the street.

Everywhere there is an explosion of brilliant red: the vermilion married women sprinkle in the parts of their hair, the carmine of turbans, the scarlet of peppers drying in the streets. To soften the glare, Indians created rose, Indian rose: whole cities painted rose-pink, rose-colored syrups and candies, rose lotuses, Pushkar roses. India burns your eyelids, your throat, your heart; the foreigner is consumed without even being aware of it.

India can be maddening, and that is why madness is also found there. "Where are the madmen?" Harun al-Rashid asks an asylum director. "By Allah, my lord," the answer comes, "we have not been able to find any for the longest time, and the shortage is probably due to the weakening of intelligence in Allah's children." But yogis and sadhus, dervishes and wise men, are saner than might be thought. They perpetuate intelligence, real intelligence—wisdom of the heart—and give India a feeling of tolerance found nowhere else in the world. Stark-naked, a man makes his way through the crowd. Nobody blinks an eye. The India in this book is the one that not only endures, but prevails, the India with something for everyone.

Roland and Sabrina Michaud

The word "India" is used in its broadest sense to include Pakistan.

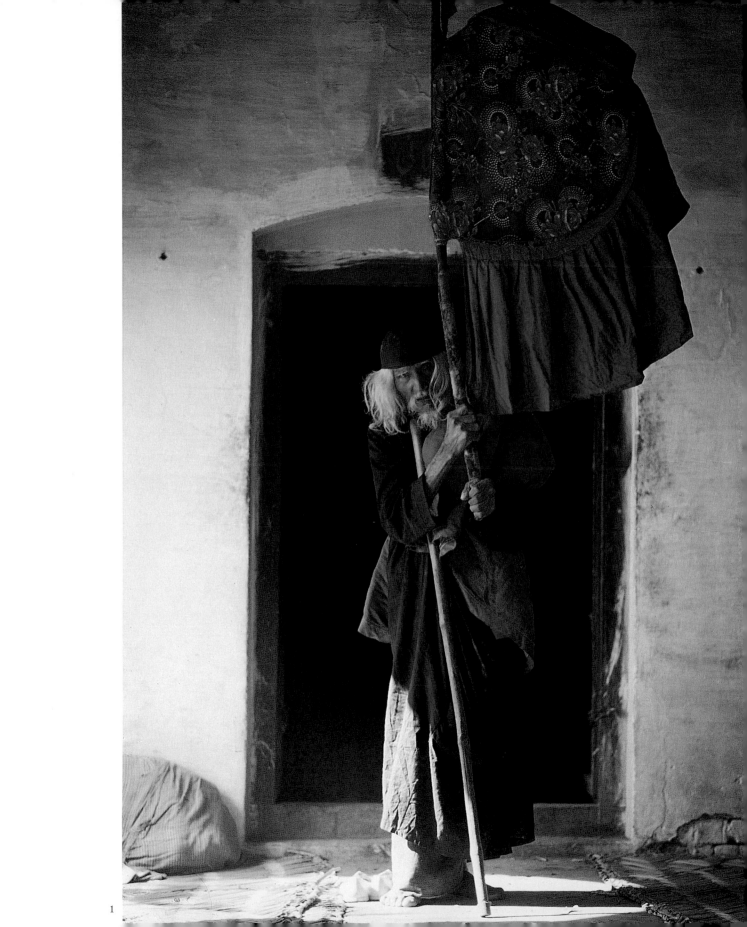

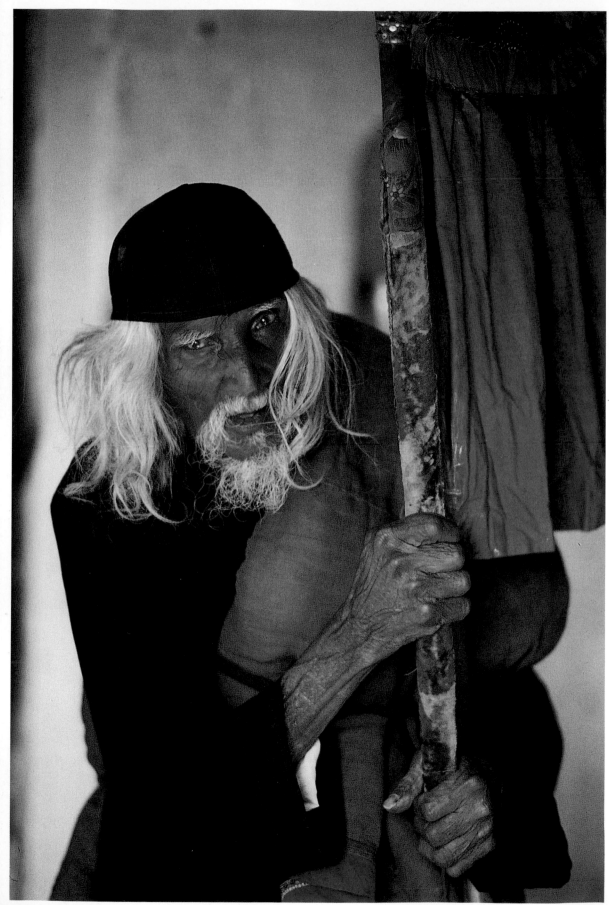

2

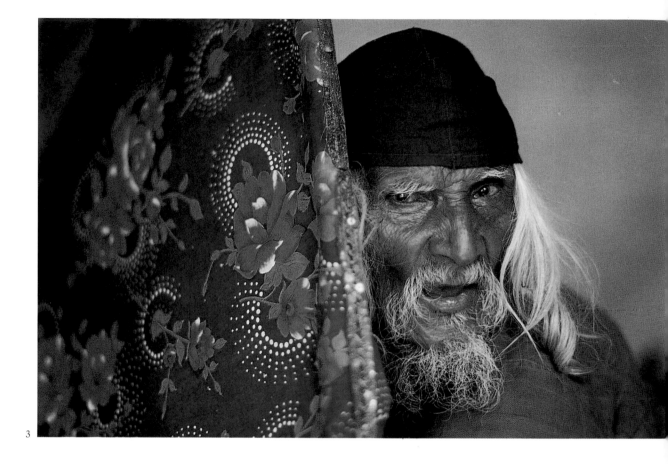

3

4

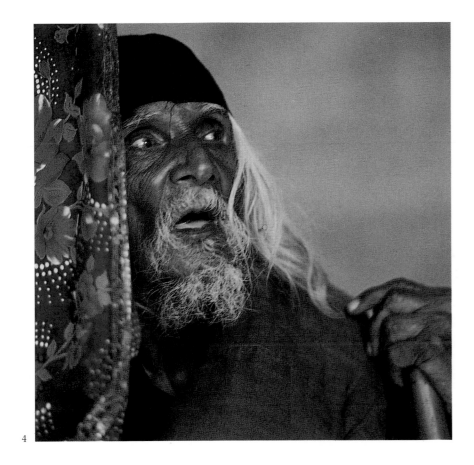

5

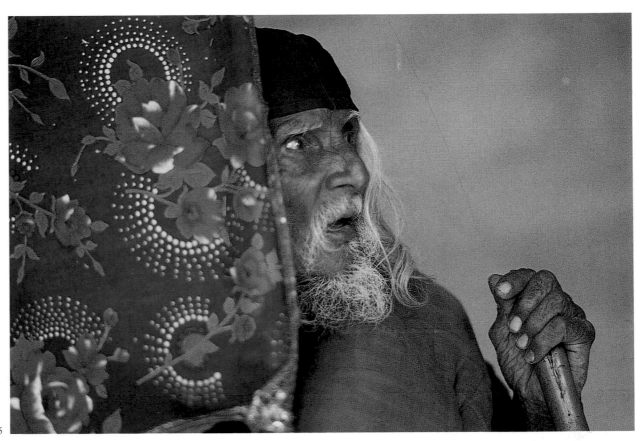

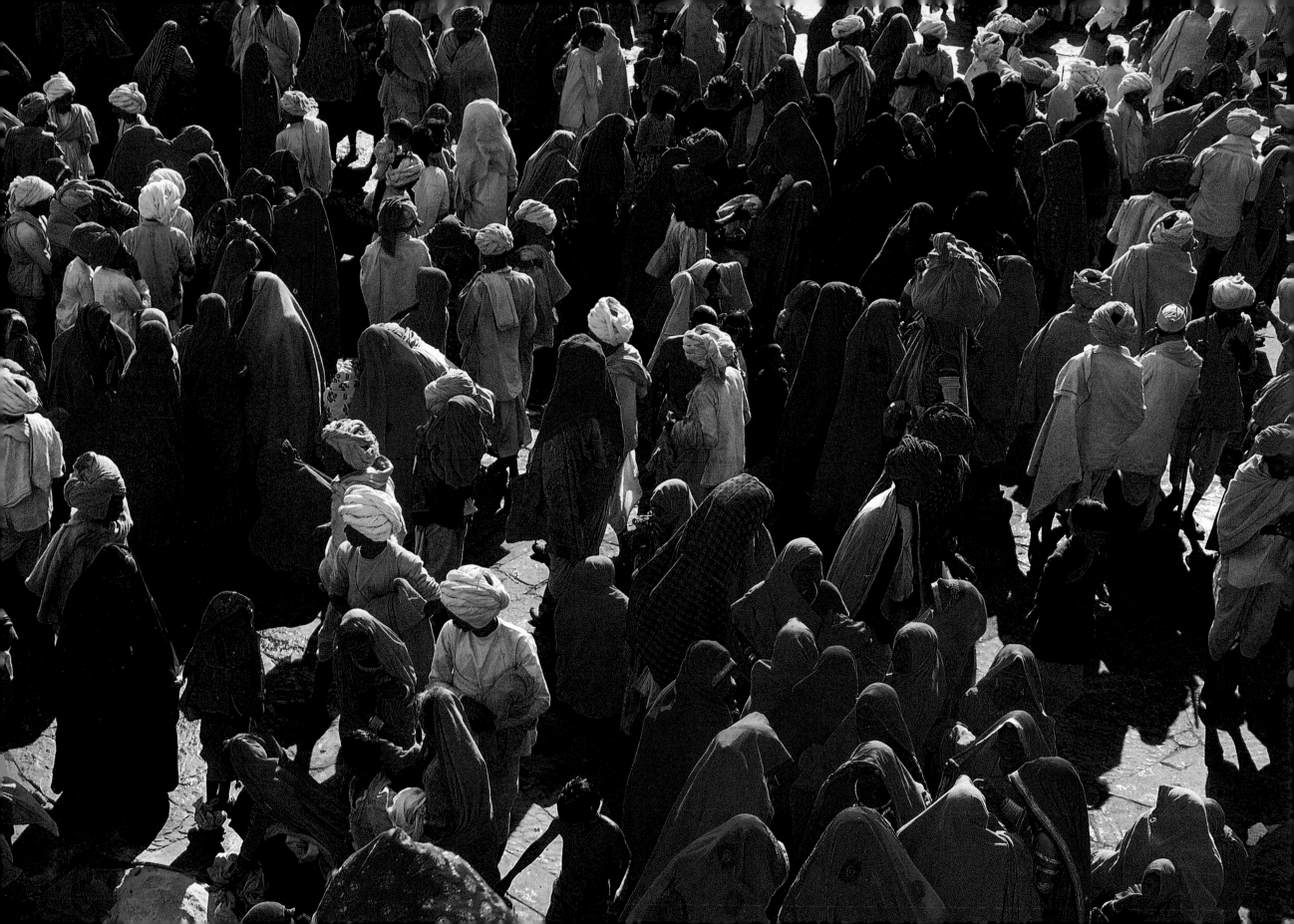

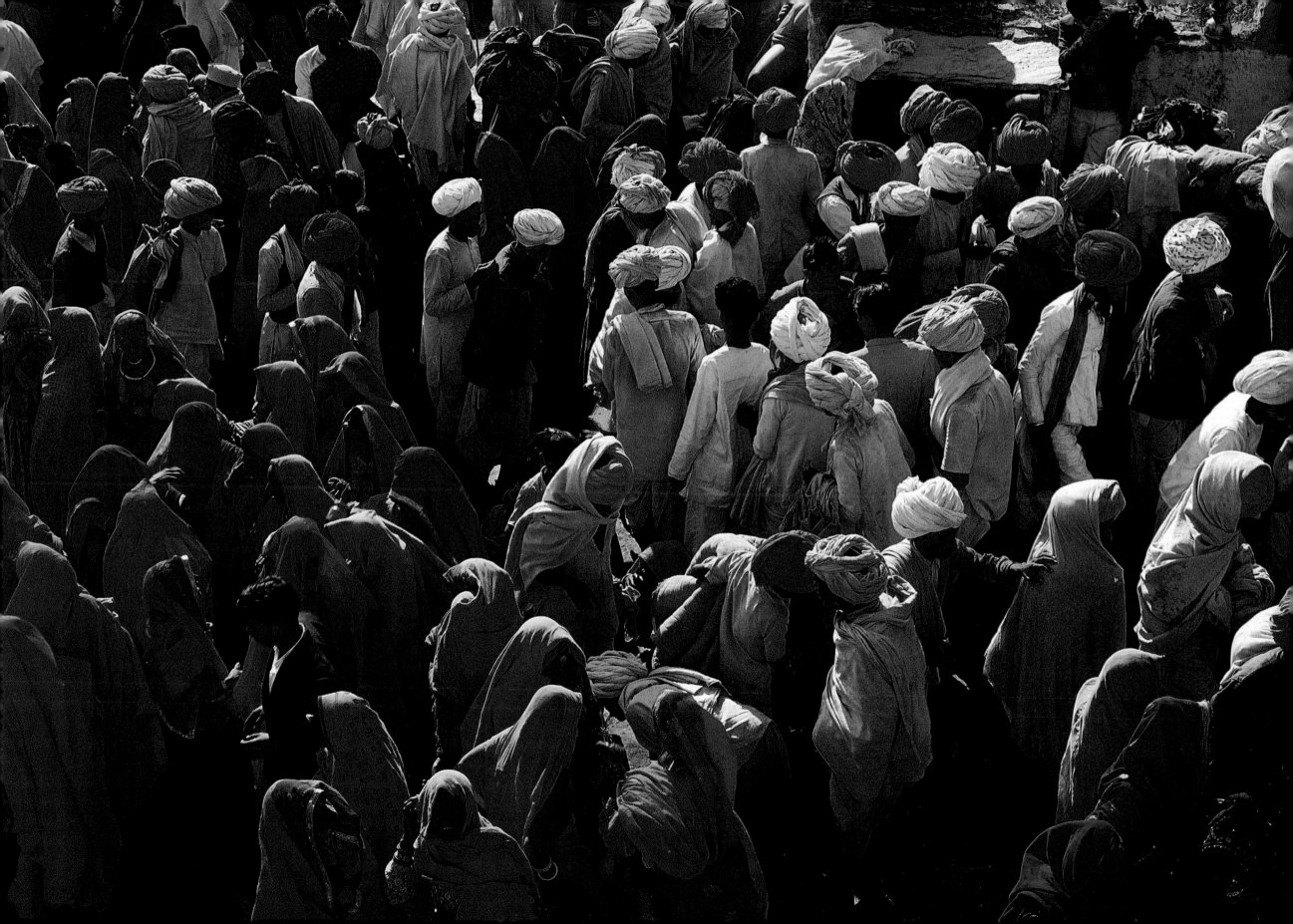

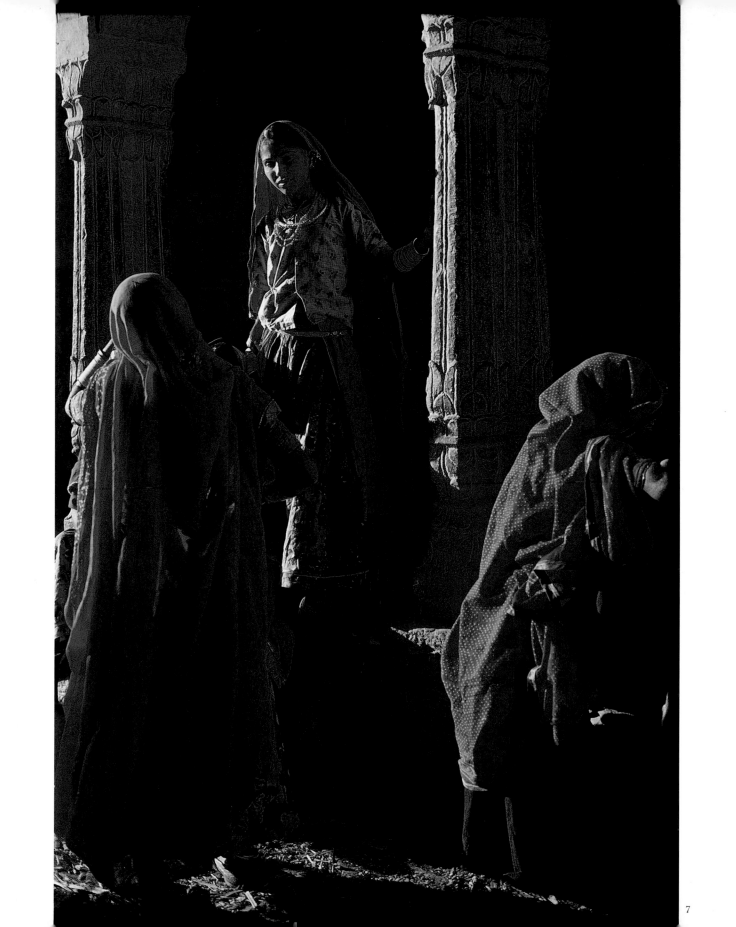

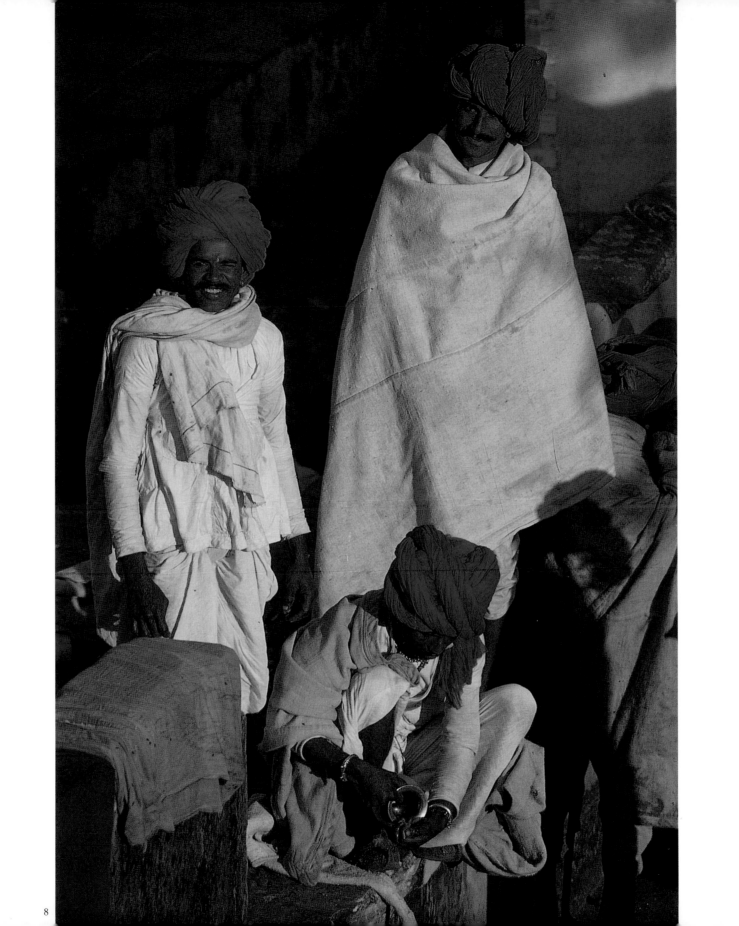

Thousand and first night

. . . *A*nd in the streets and markets the people burned incense, sublimated camphor, aloes, Indian musk, nard, and ambergris. They put fresh henna upon their fingers and saffron upon their faces. Drums, flutes, clarinets, fifes, cymbals, and dulcimers filled every ear with a rejoicing sound.

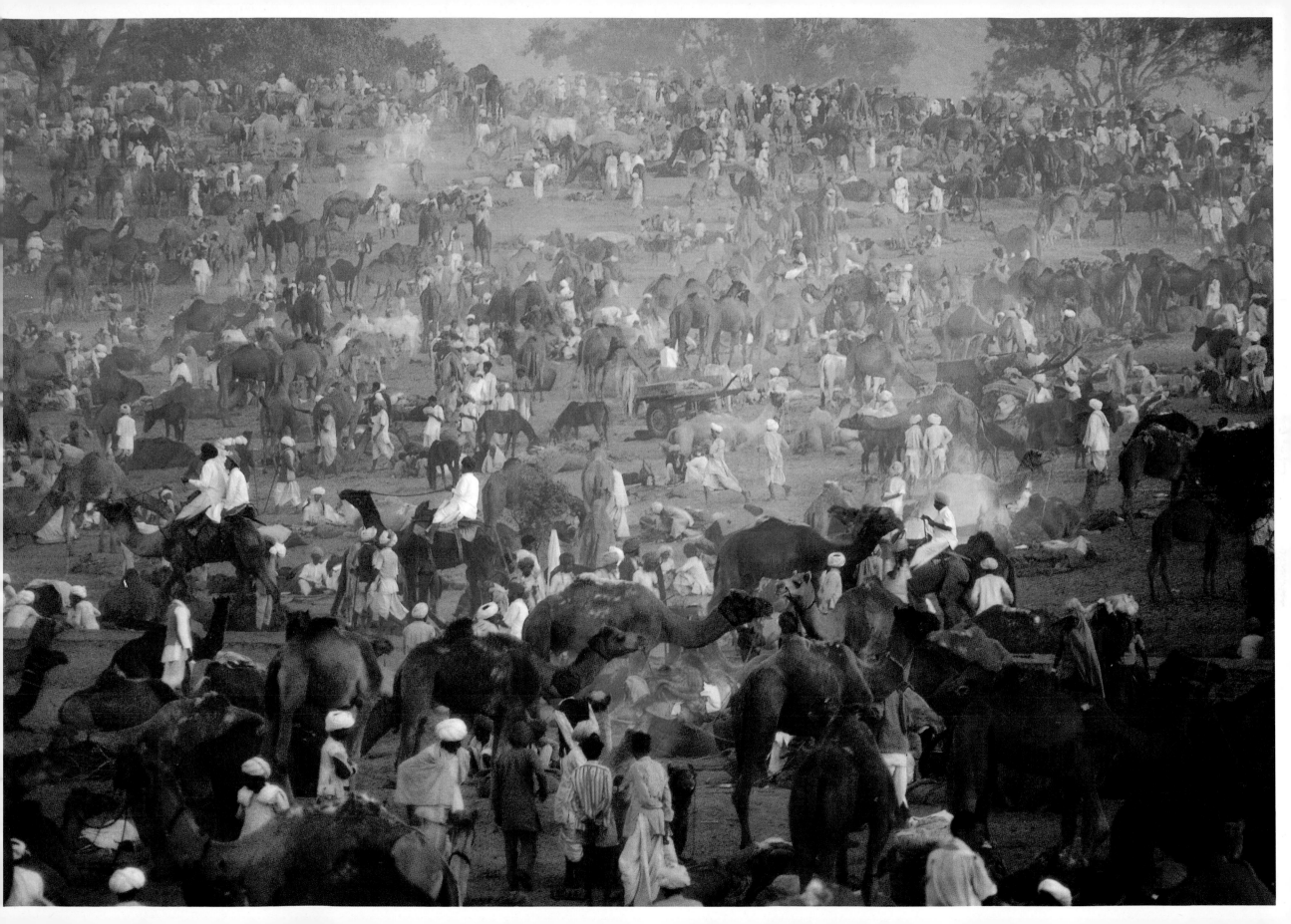

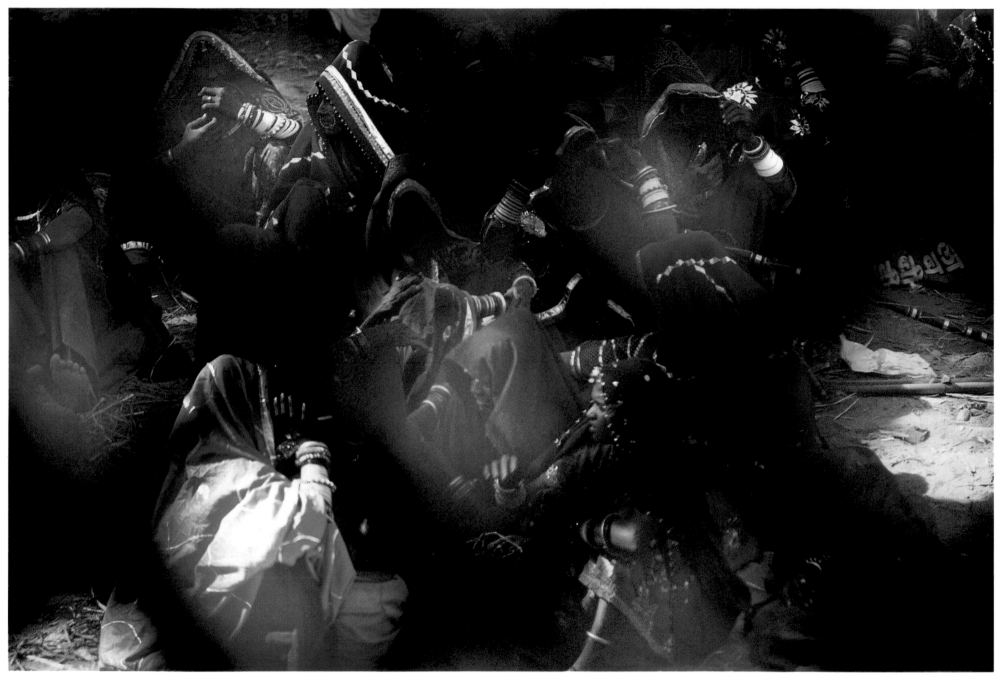

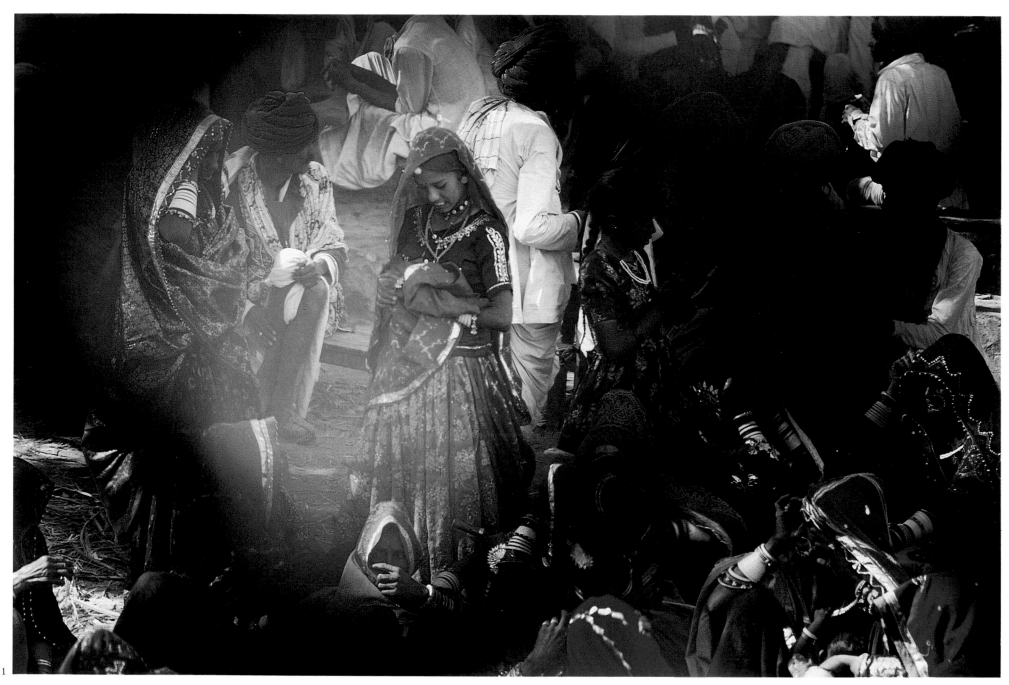

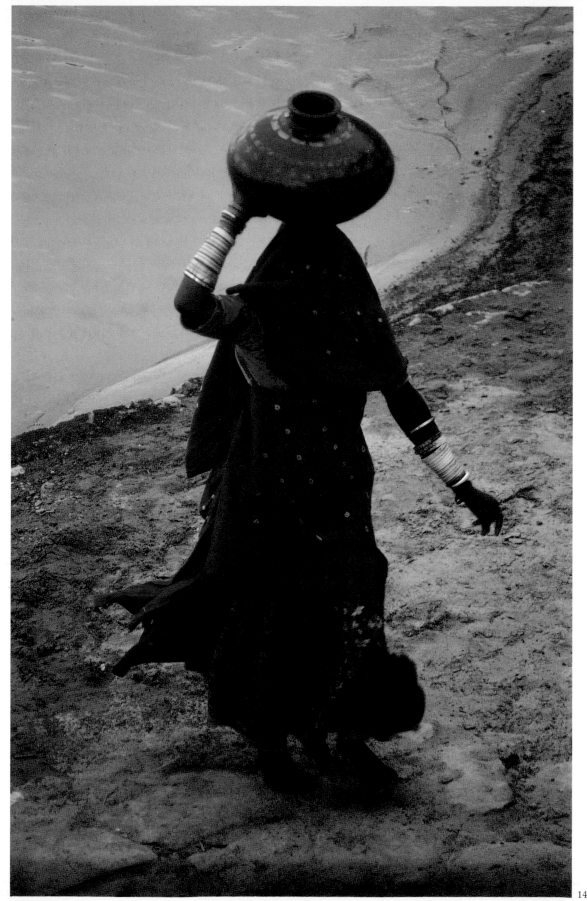

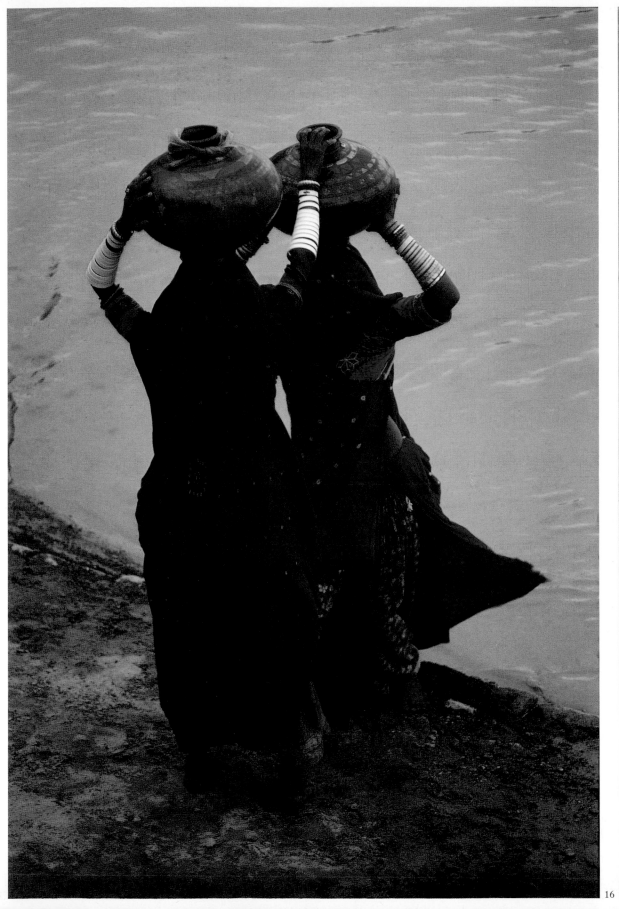

15

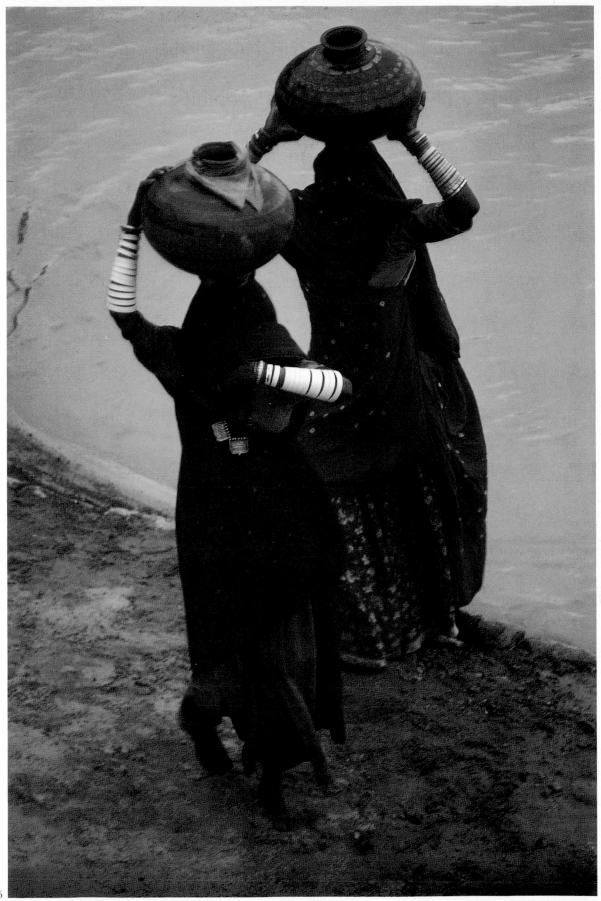

16

Eight hundred and fifty-first night

The Tale of Ali Baba and the Forty Thieves

. . . *And he could judge by their dark faces, eyes as of new copper, and beards parted terribly in the center like the wings of a carrion crow, that he was in the presence of the worst kind of outlaw robbers.*

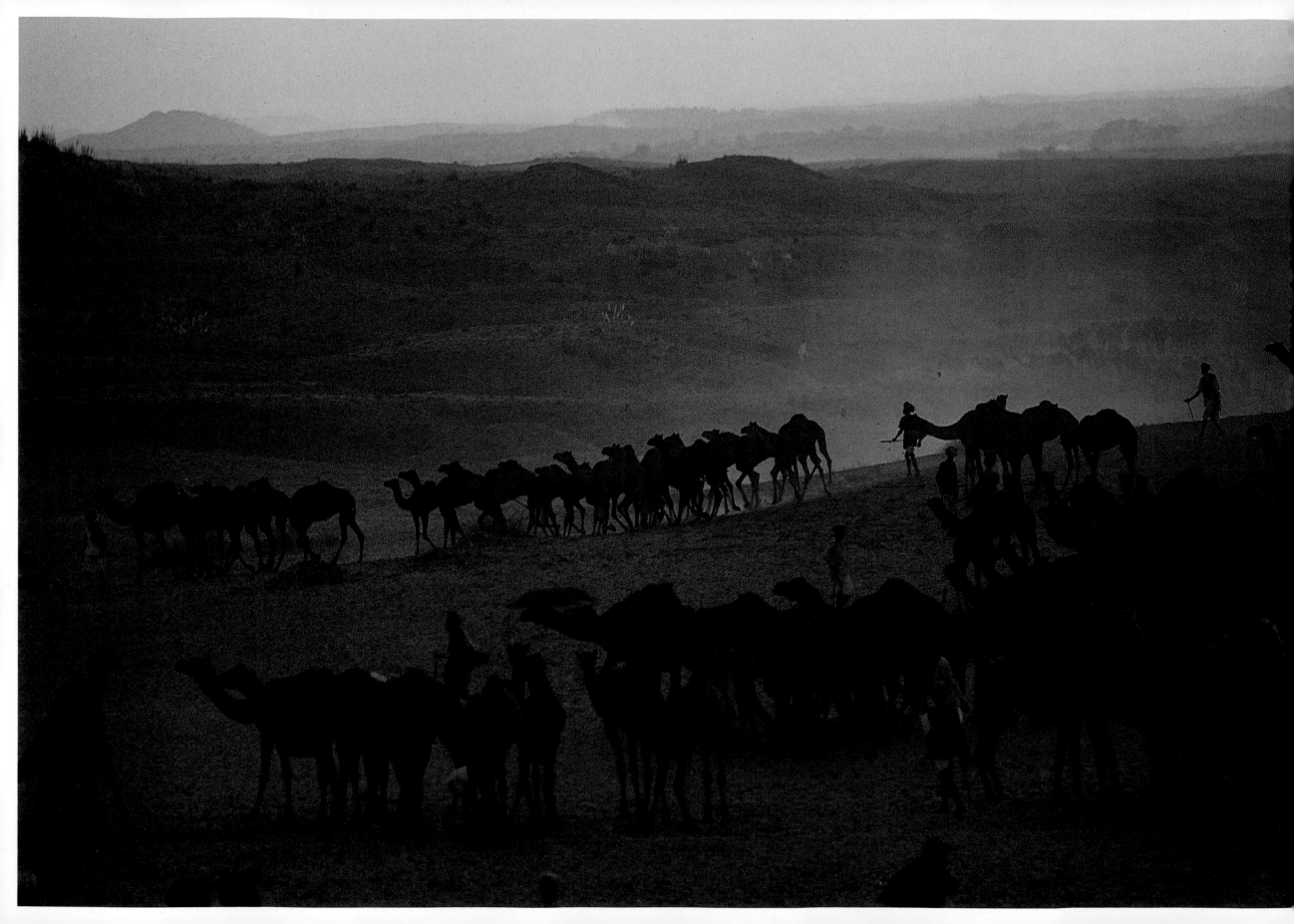

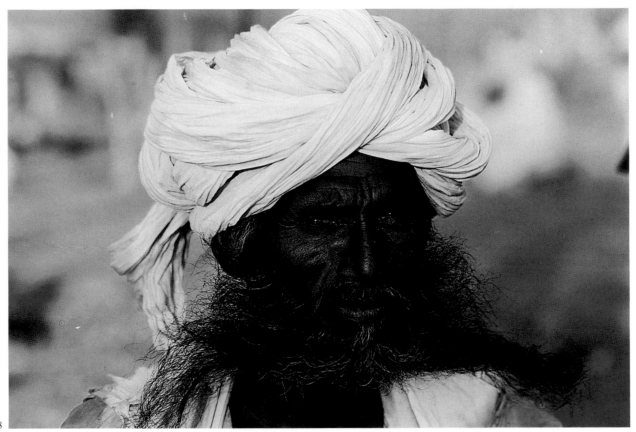

18

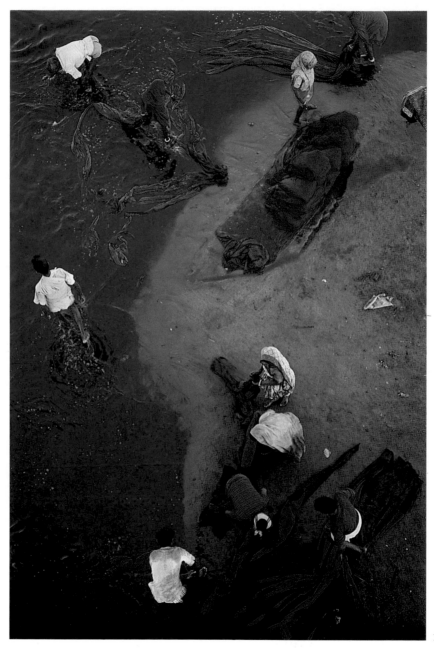

19

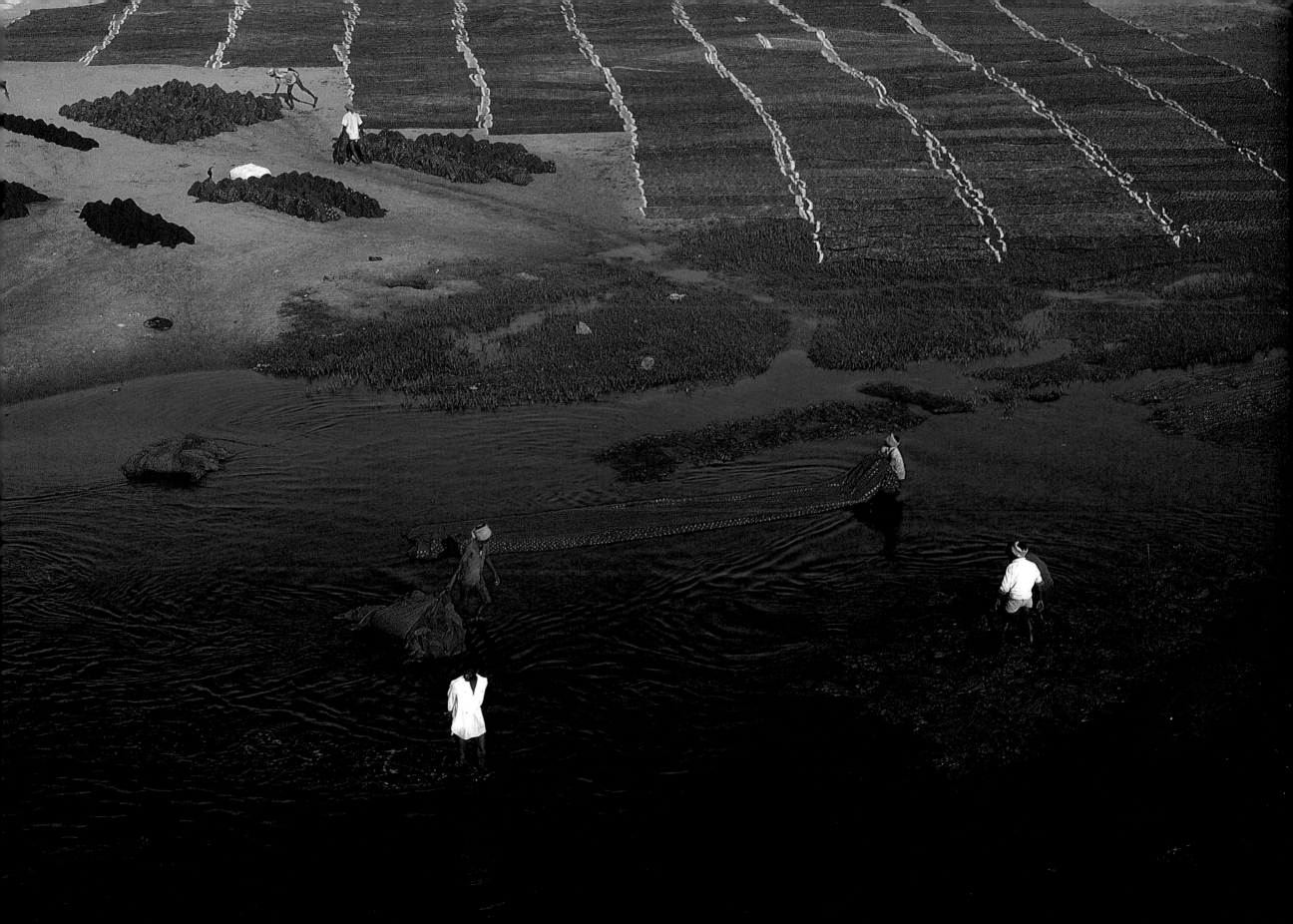

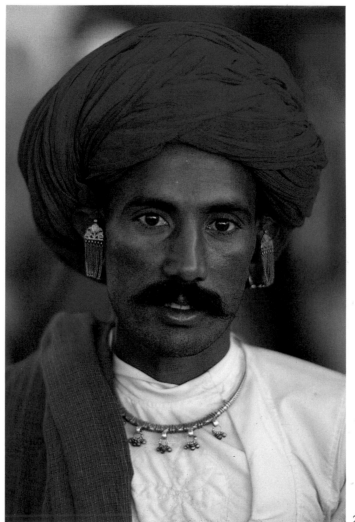

21

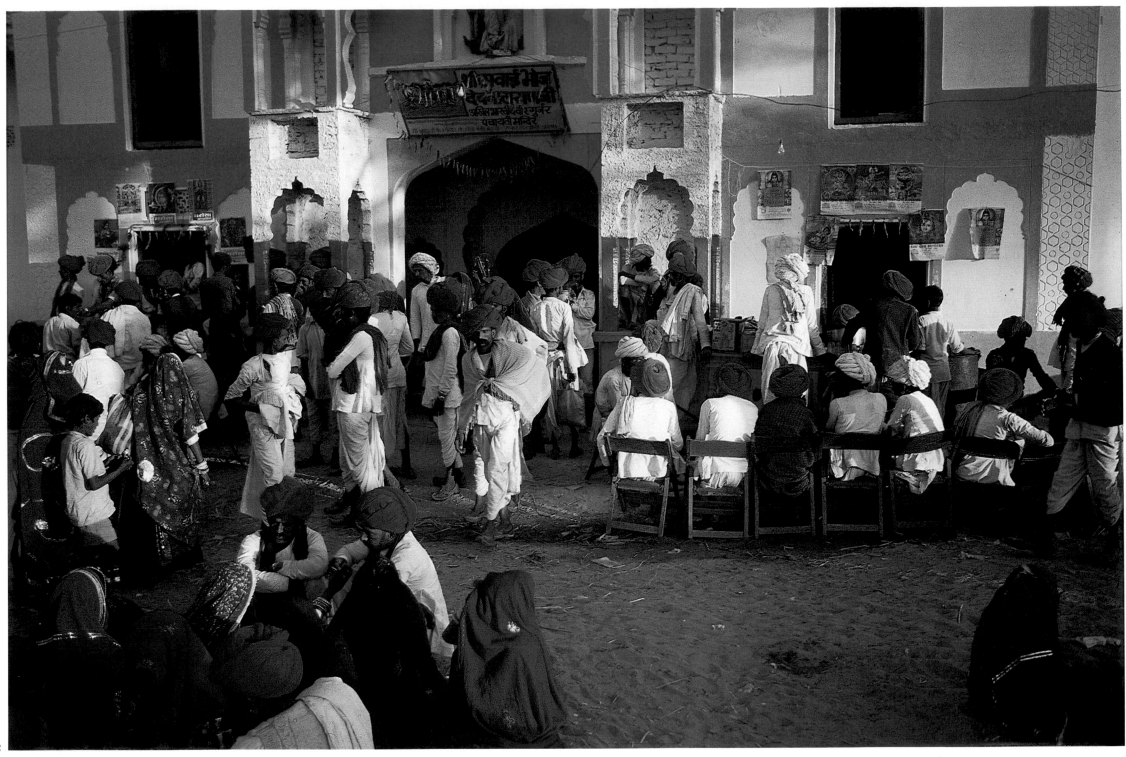

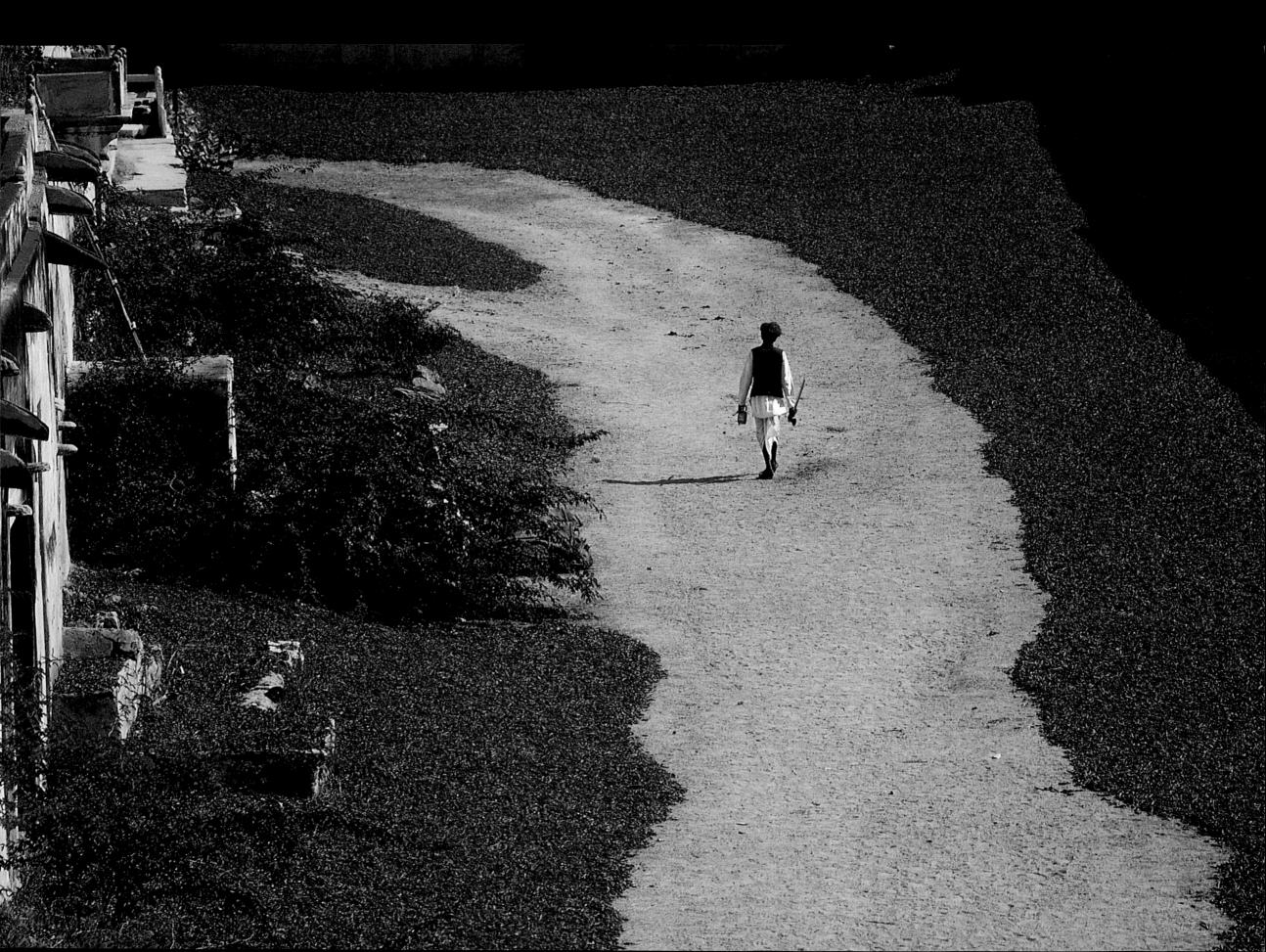

Three hundred and thirteenth night

The Tale of Sindbad the Sailor

I am called Sindbad the Sailor, because of the many voyages I have made upon the sea. Those strange things which I have seen would serve as a lesson for the attentive reader even were they written with a needle upon the corner of an eye.

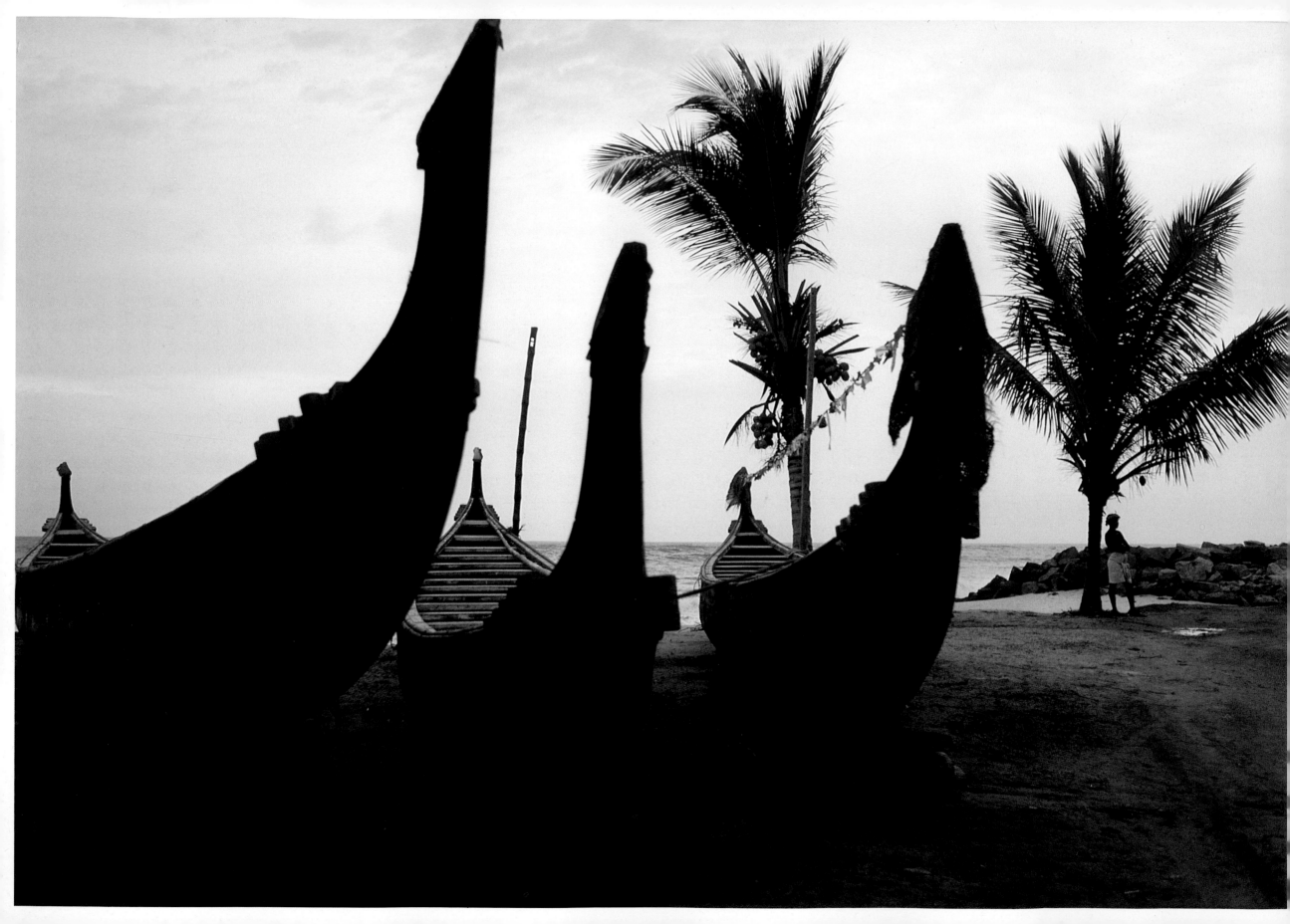

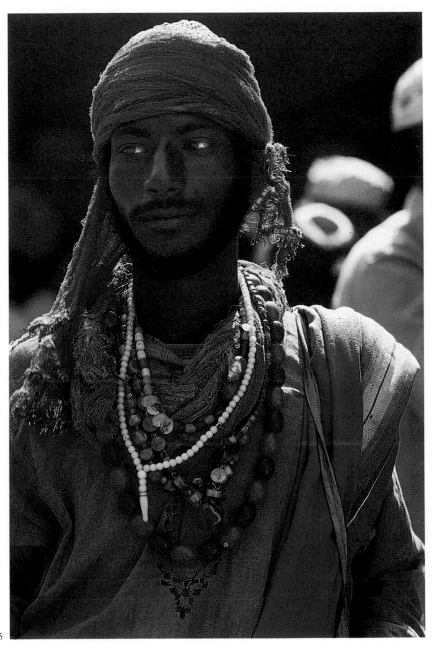

25

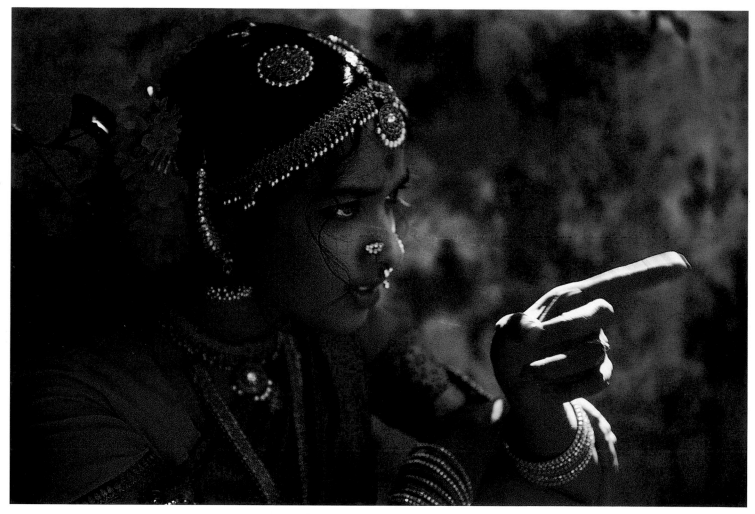

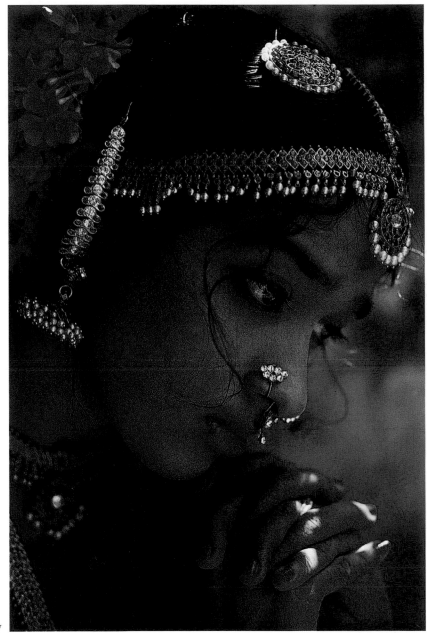

27

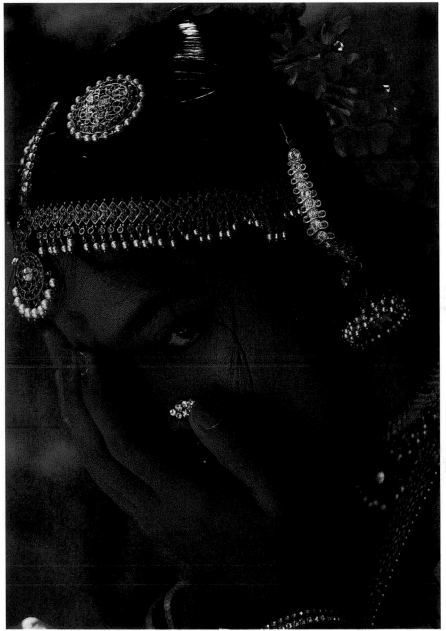

28

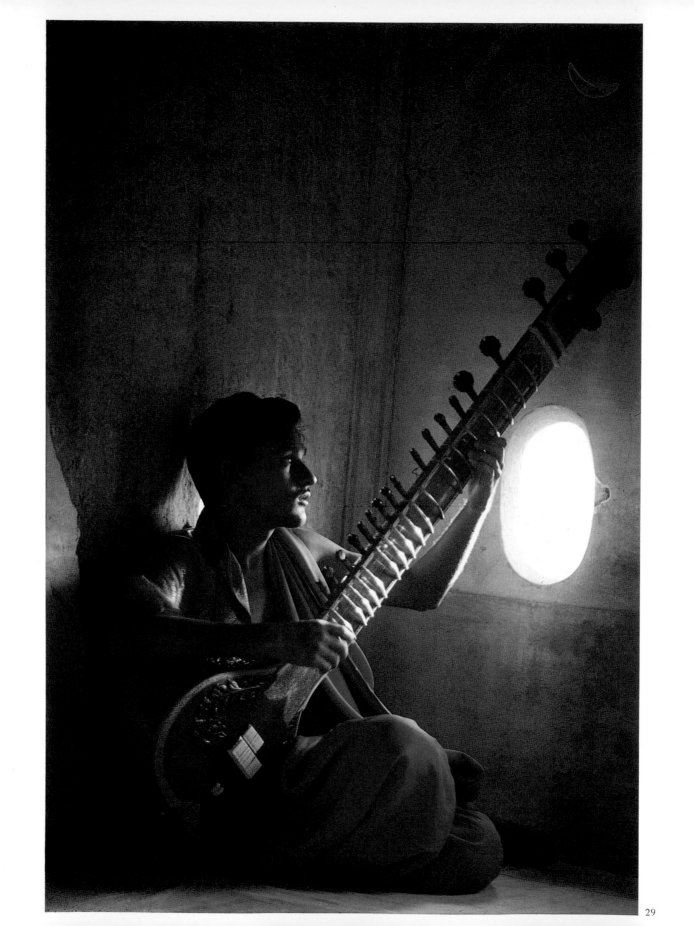

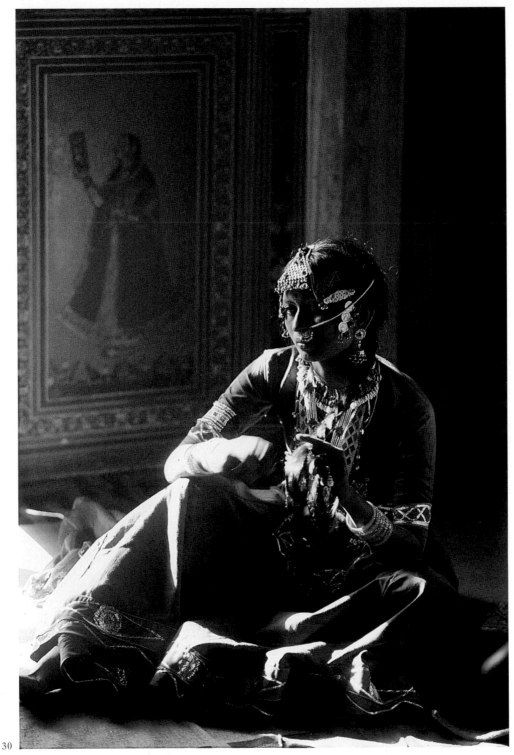

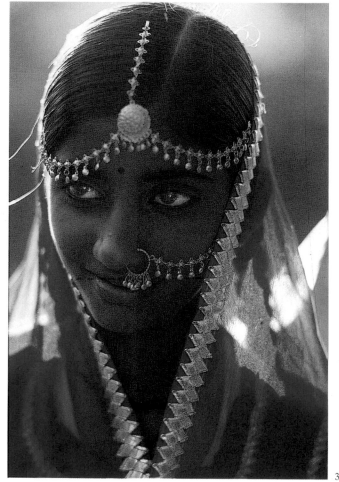

31

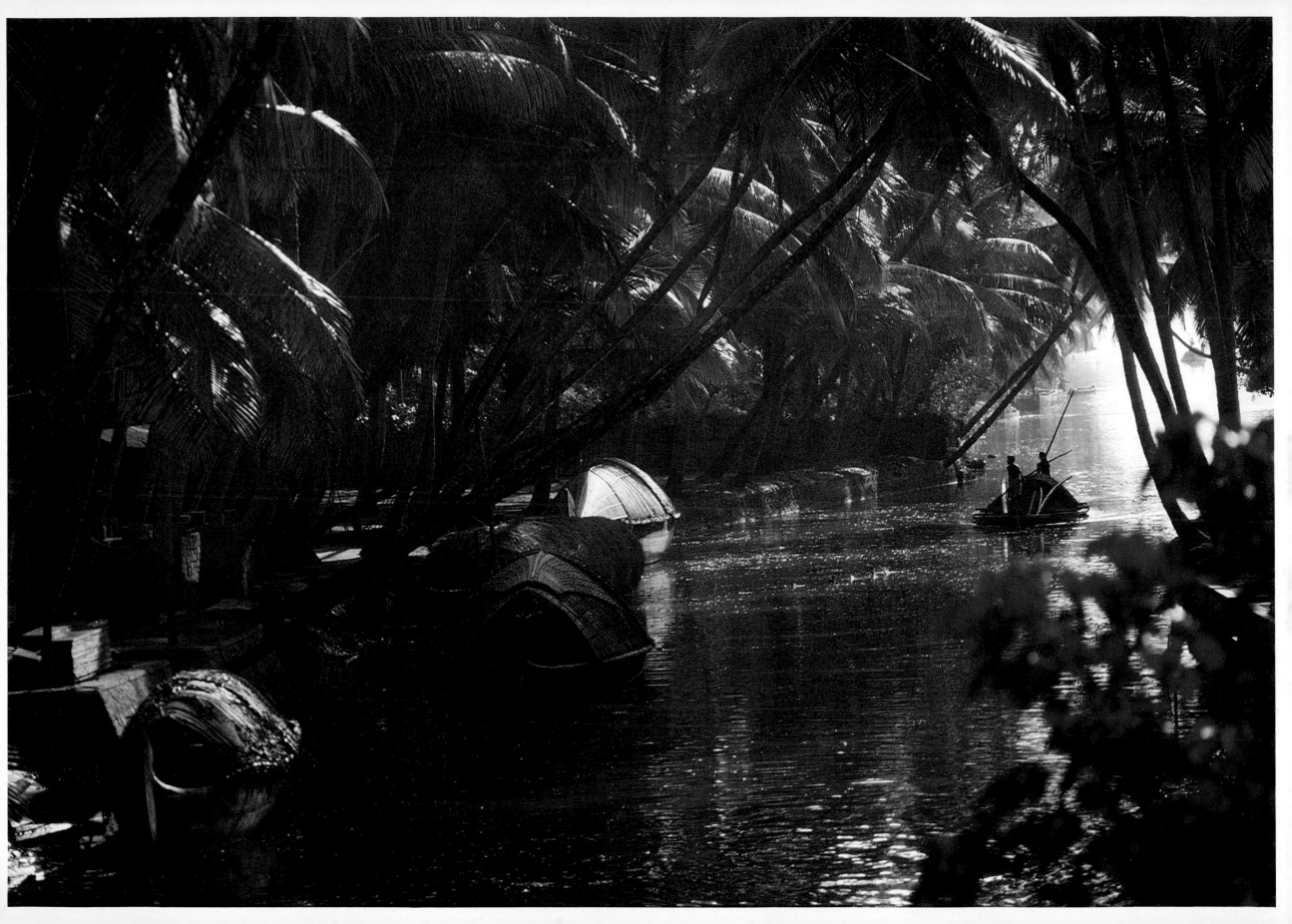

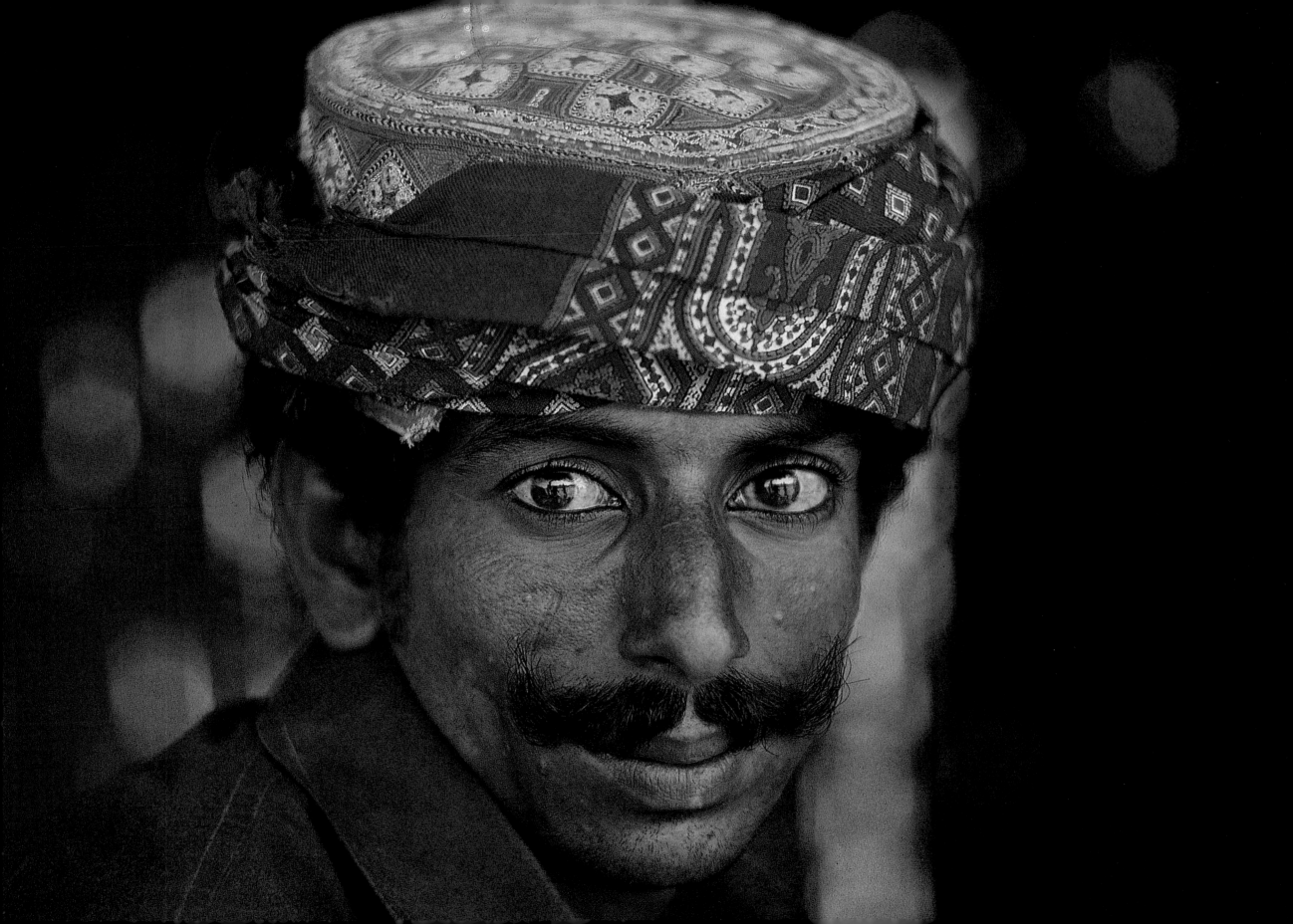

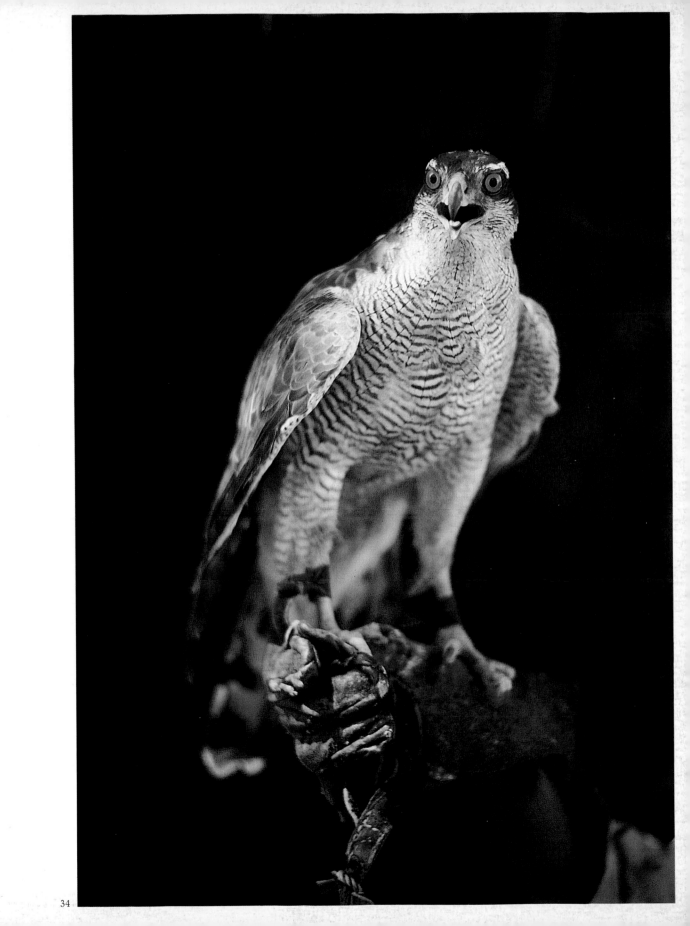

Eight hundred and fifty-ninth night

The Tale of Ali Baba
and the Forty Thieves

... *She was dressed as a dancer, her brow starred with gold sequins, her neck hung with beads of yellow amber, her waist pressed in a supple belt of gold, and having sounding gold upon her wrists and ankles. She danced tirelessly and with all perfection, as the shepherd David danced before the black sadness of Saul.*

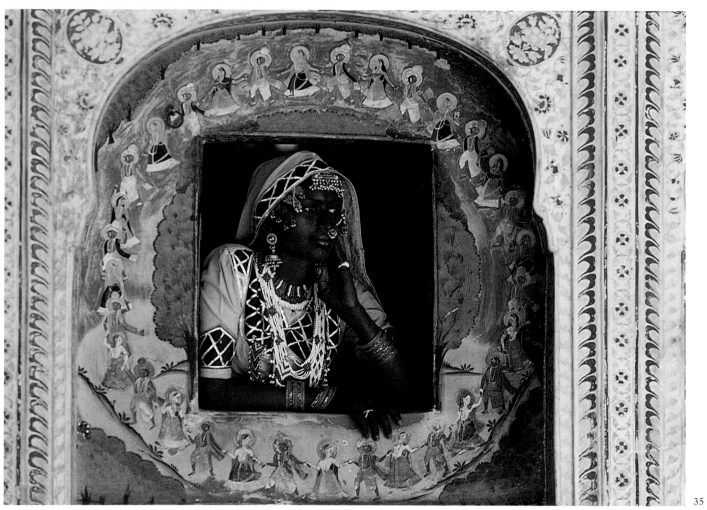

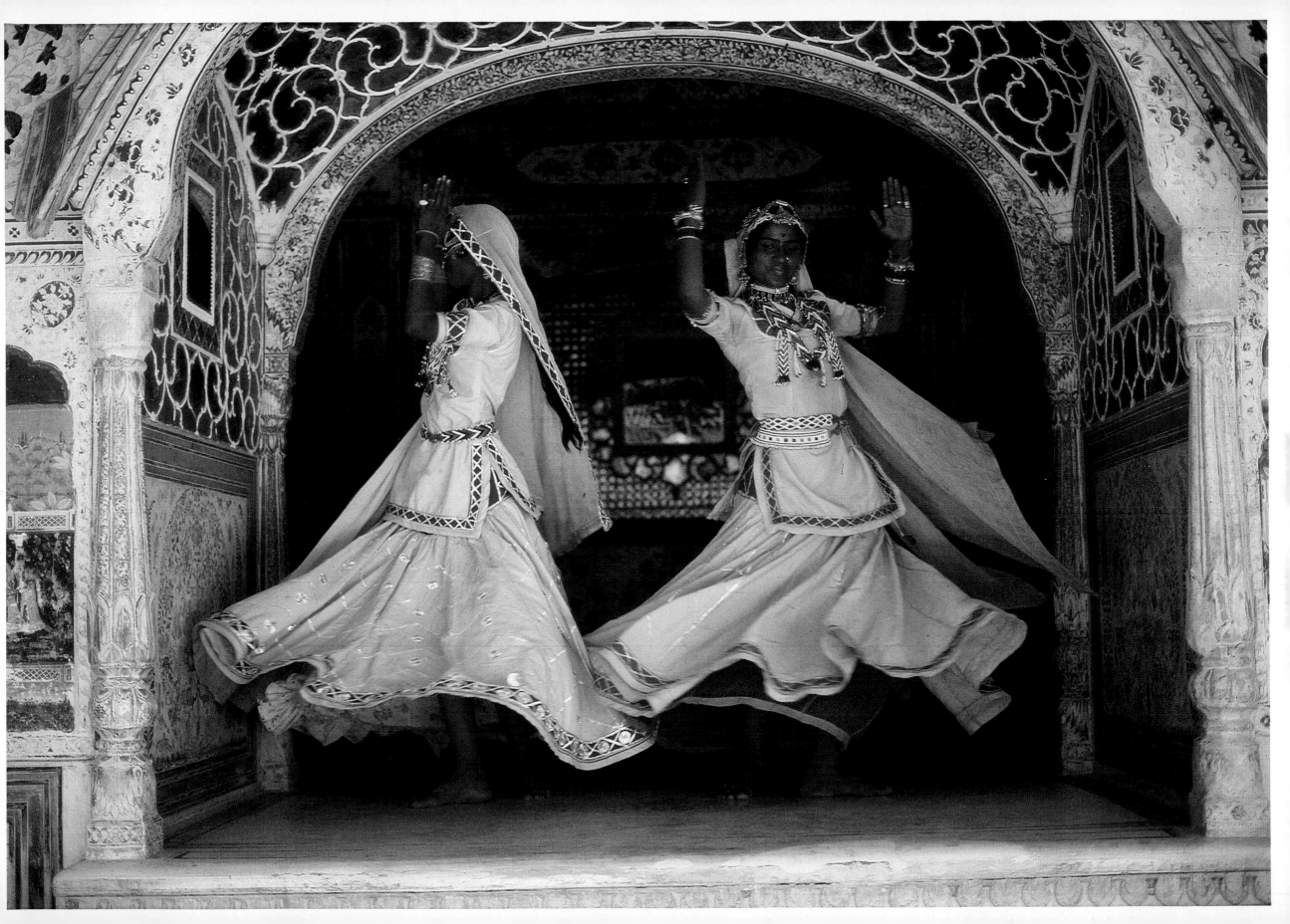

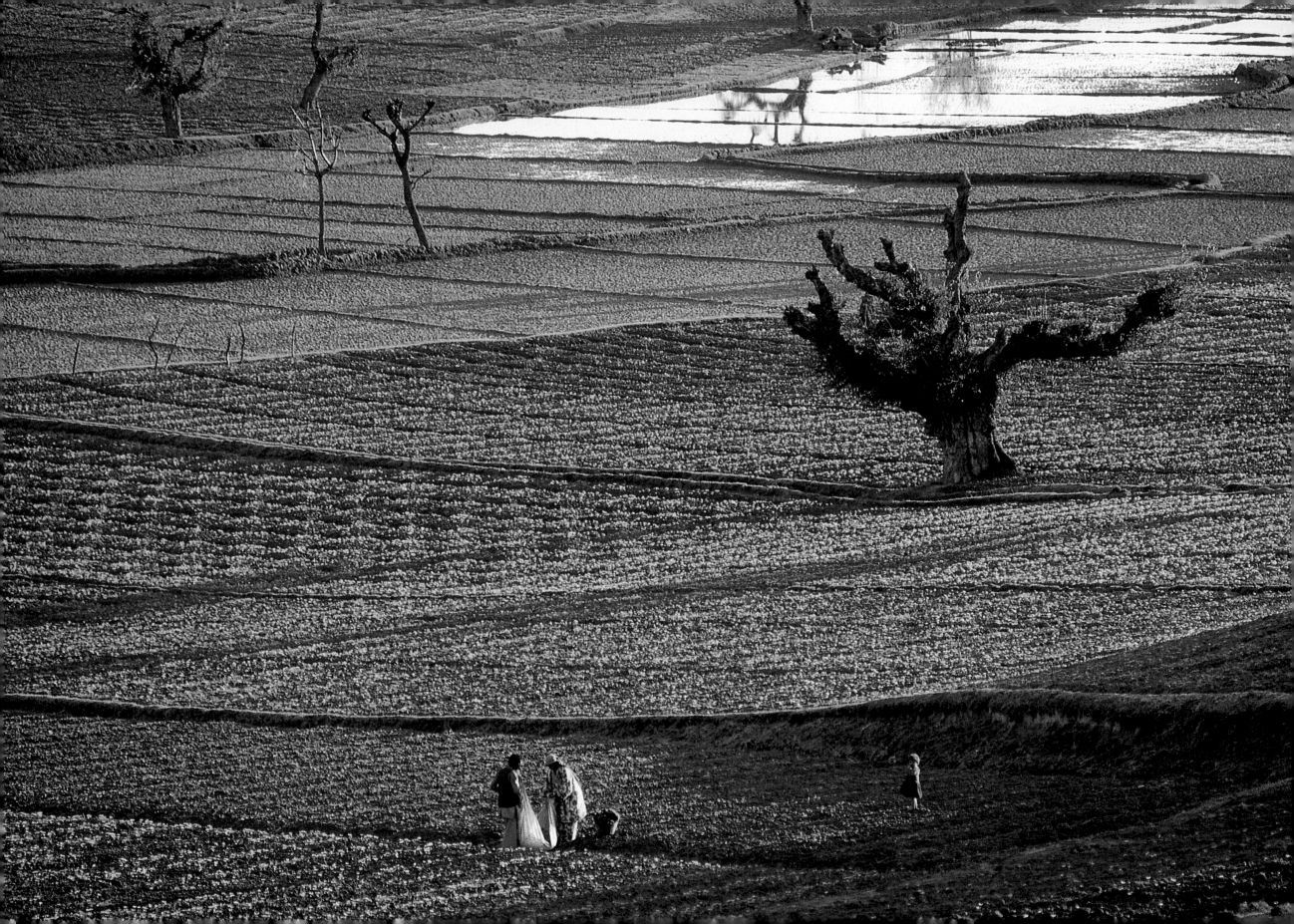

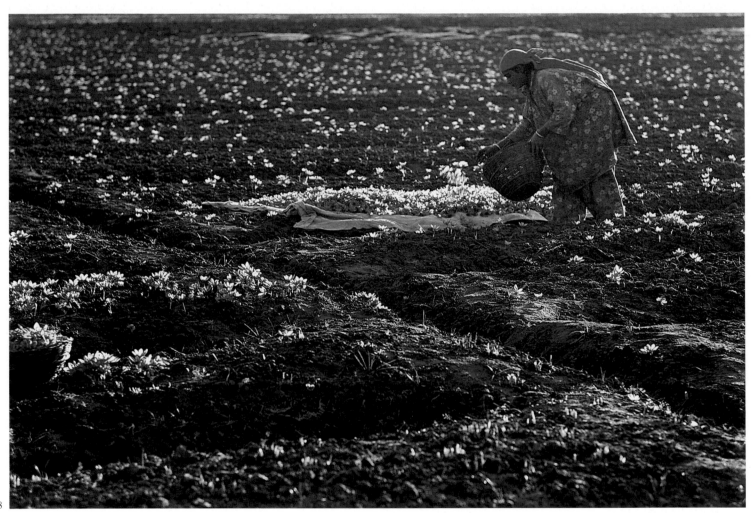

38

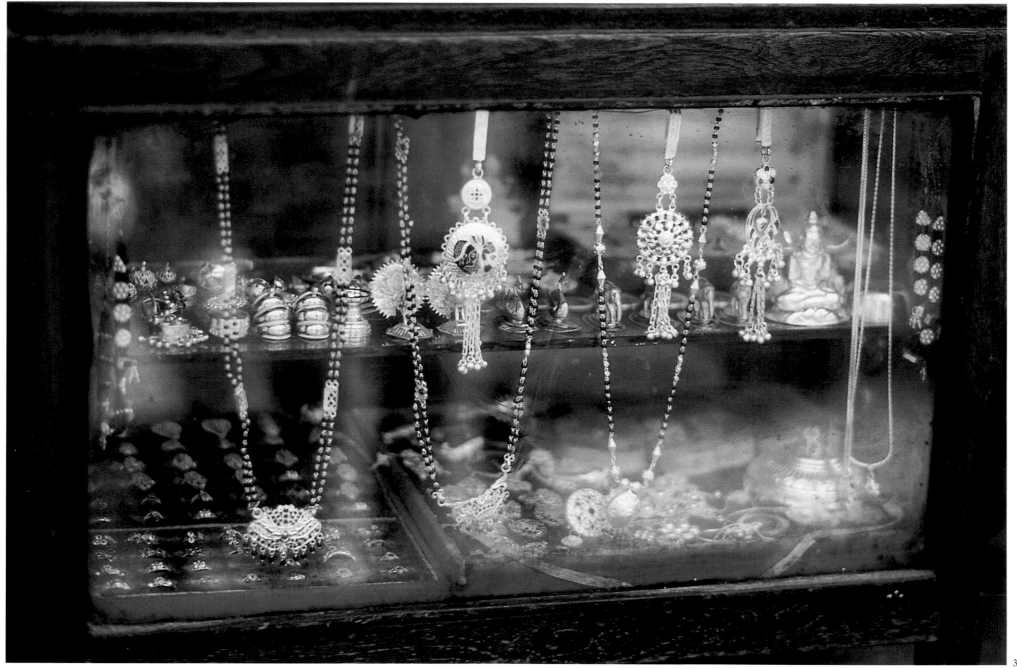

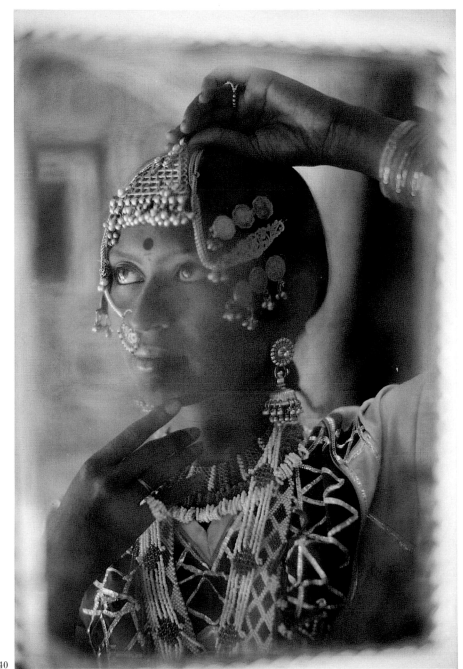

40

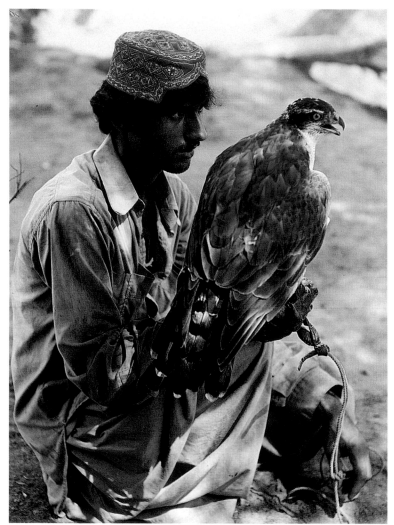

41

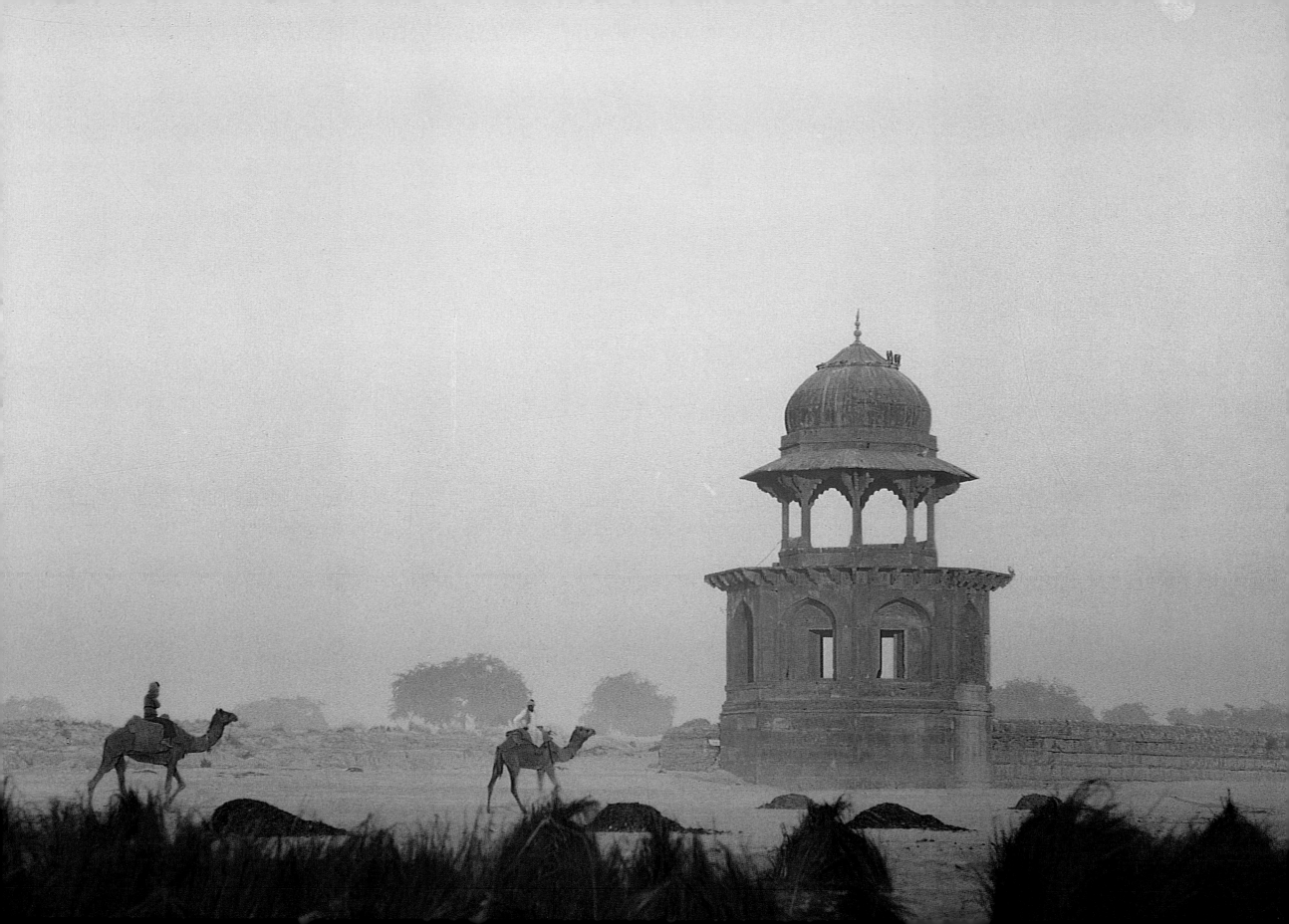

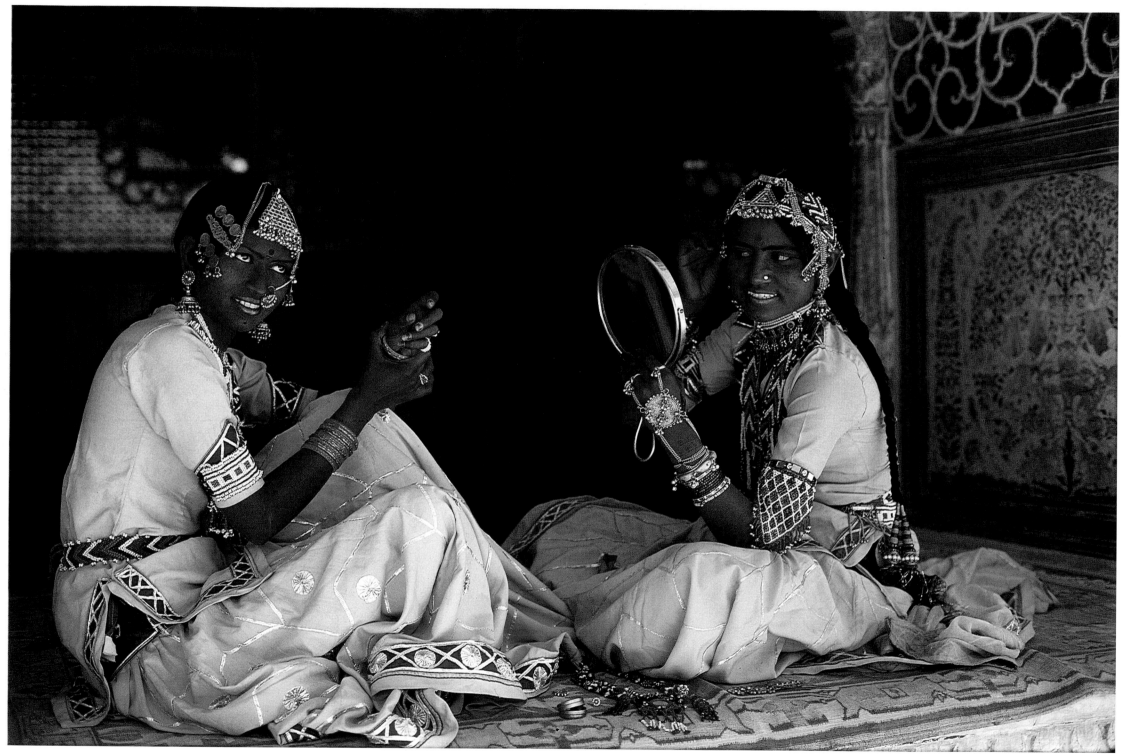

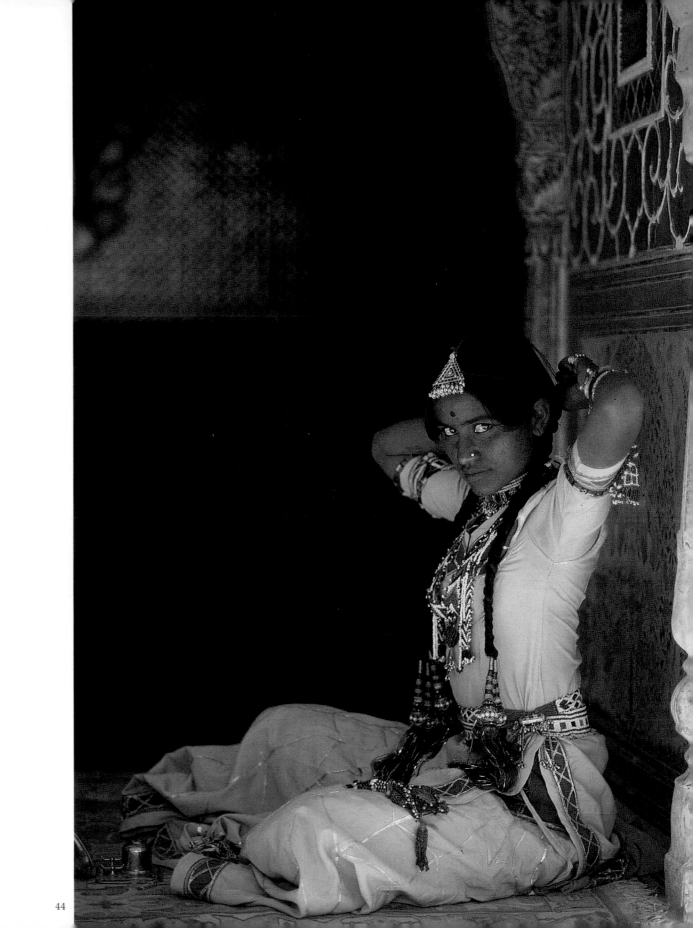

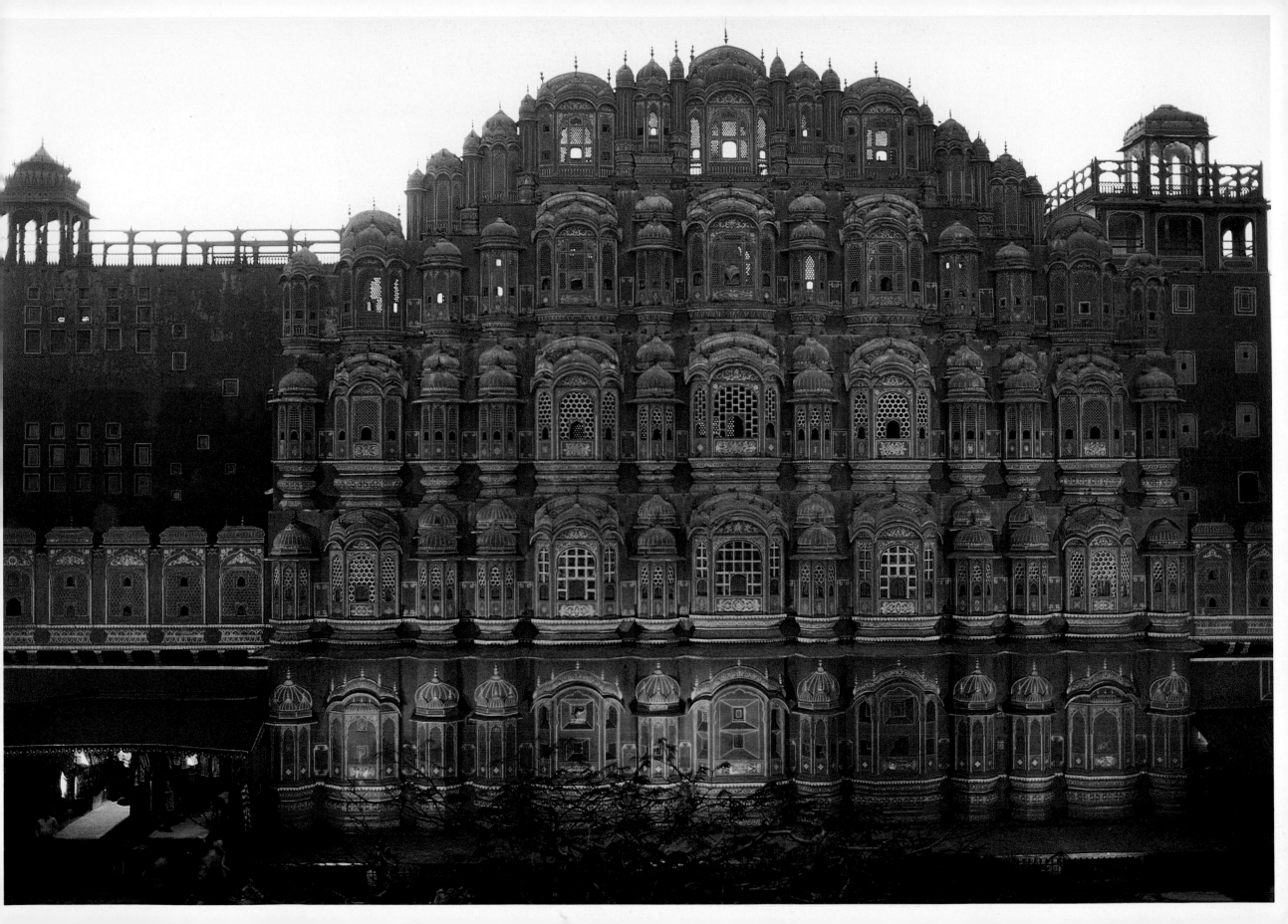

The Tale of the Shifts
of Delilah-the-Wily
and her Daughter Zainab-the-Cheat,
with Ahmad-the-Moth,
Hasan-the-Pest and
Ali Quicksilver

She walked slowly through the markets of Baghdad, undulating her hips and moving her eyes beneath their little veil; her path was strewn with destructive glances, with smiles for some, silent promises for others, coquetries and temptations, with eye answers and lashes' questioning, murders with the lids, awakening by bracelets, music of anklets and general fire for all.

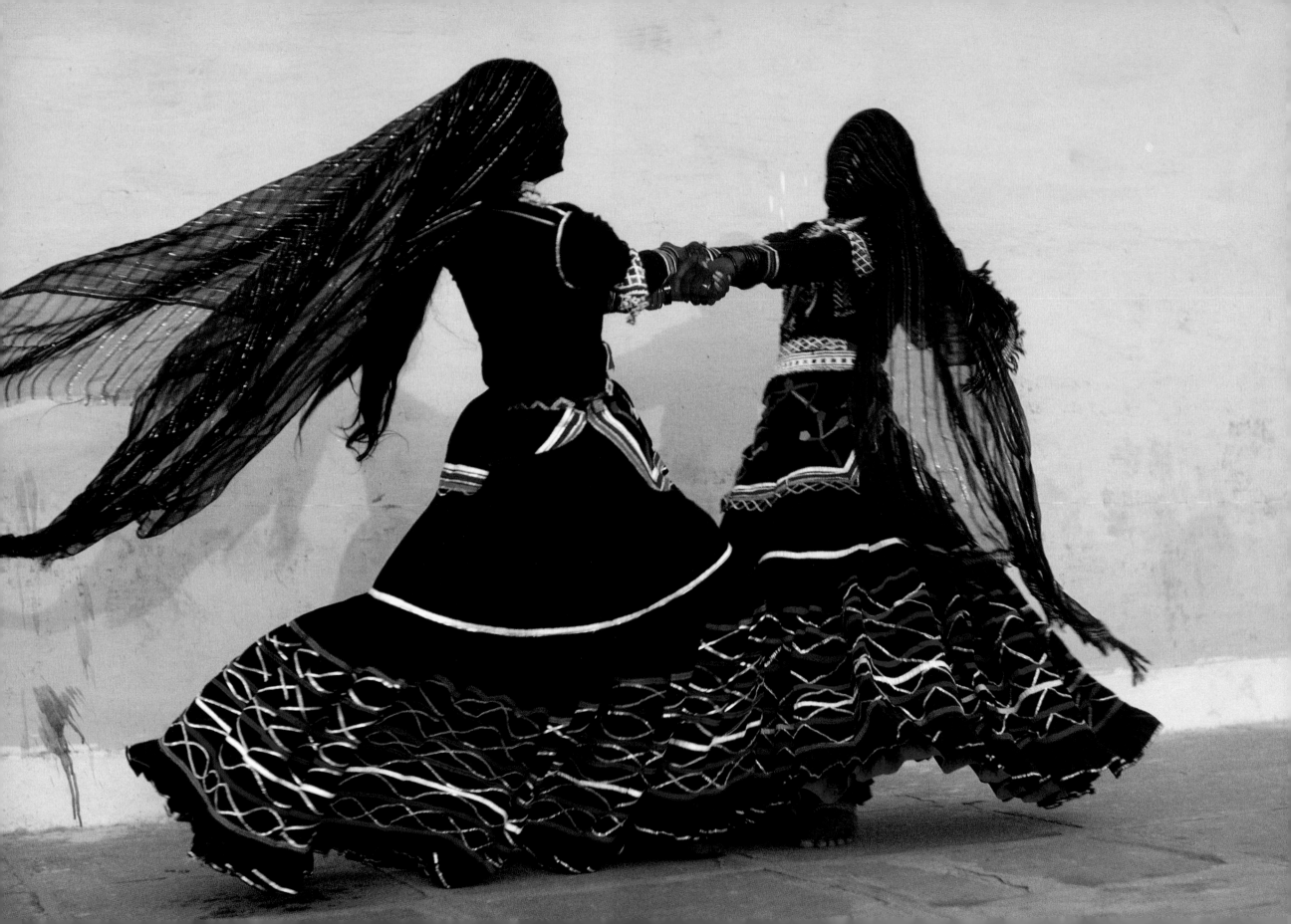

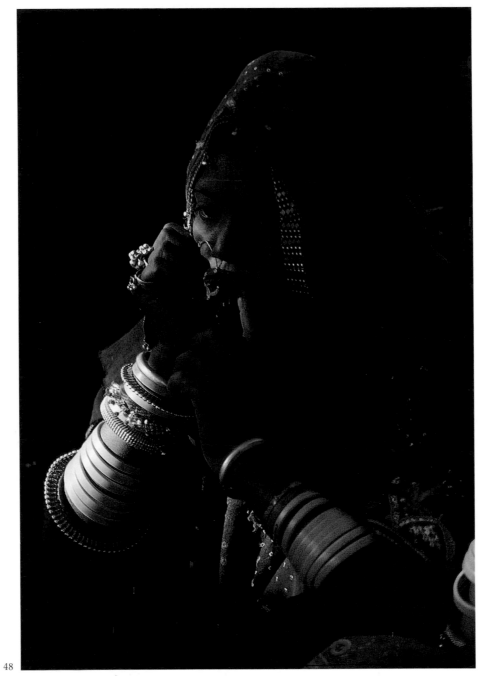

48

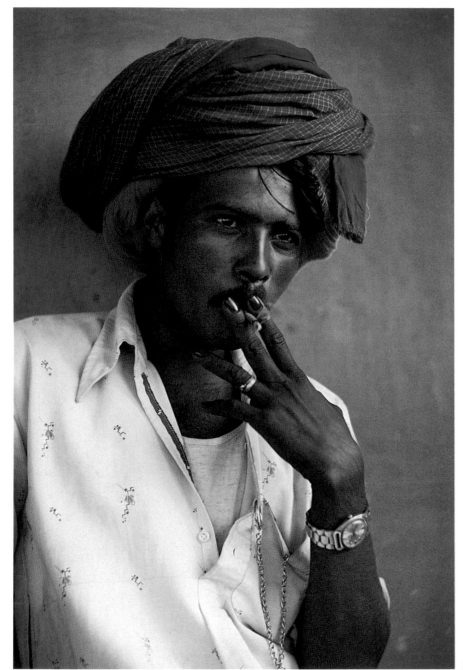

51

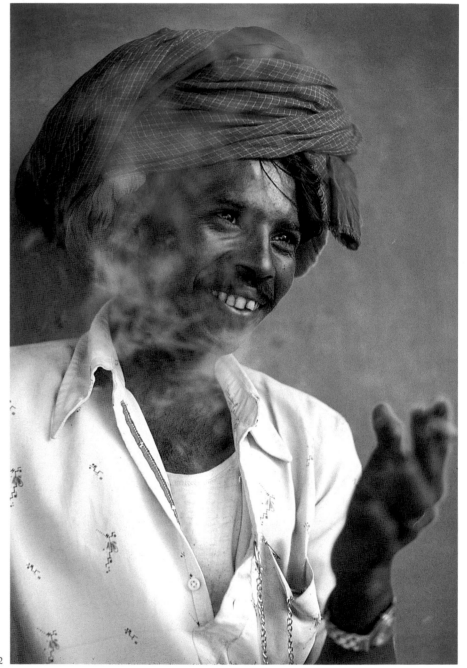

52

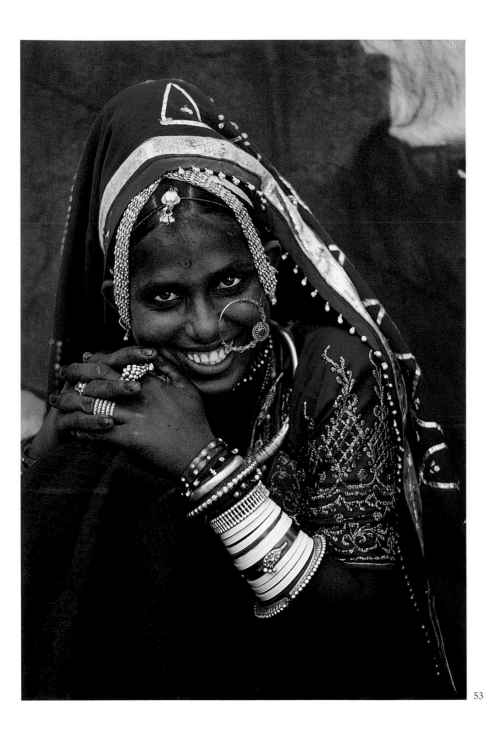

53

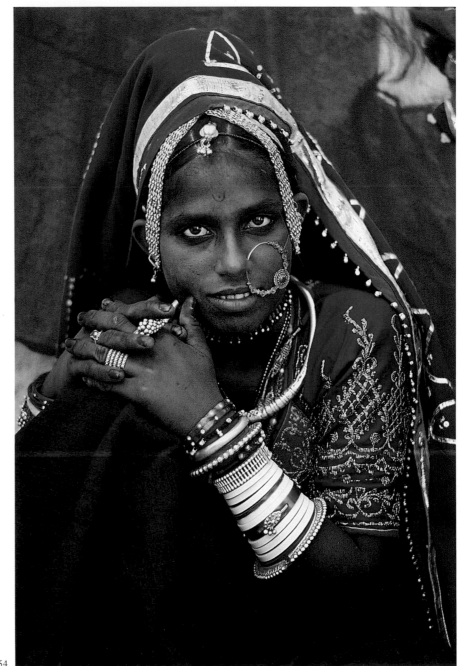

54

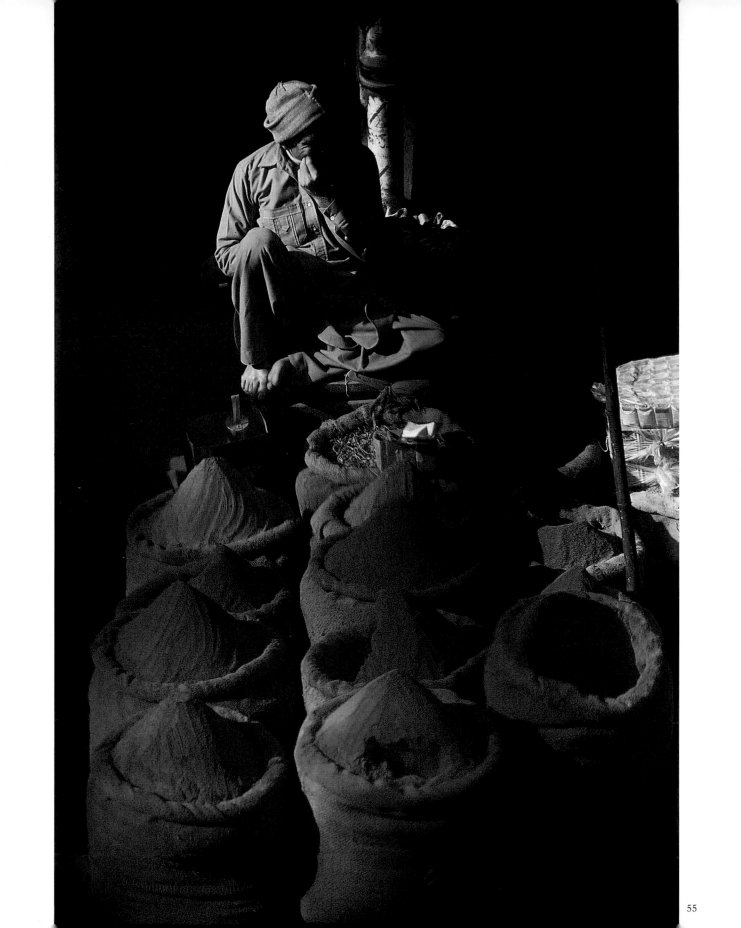

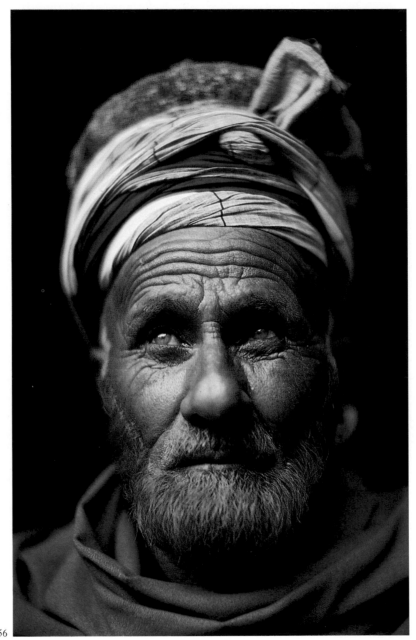

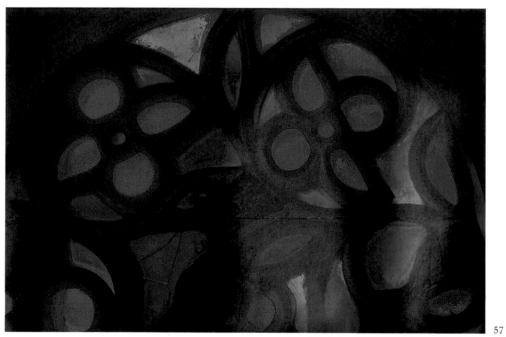

57

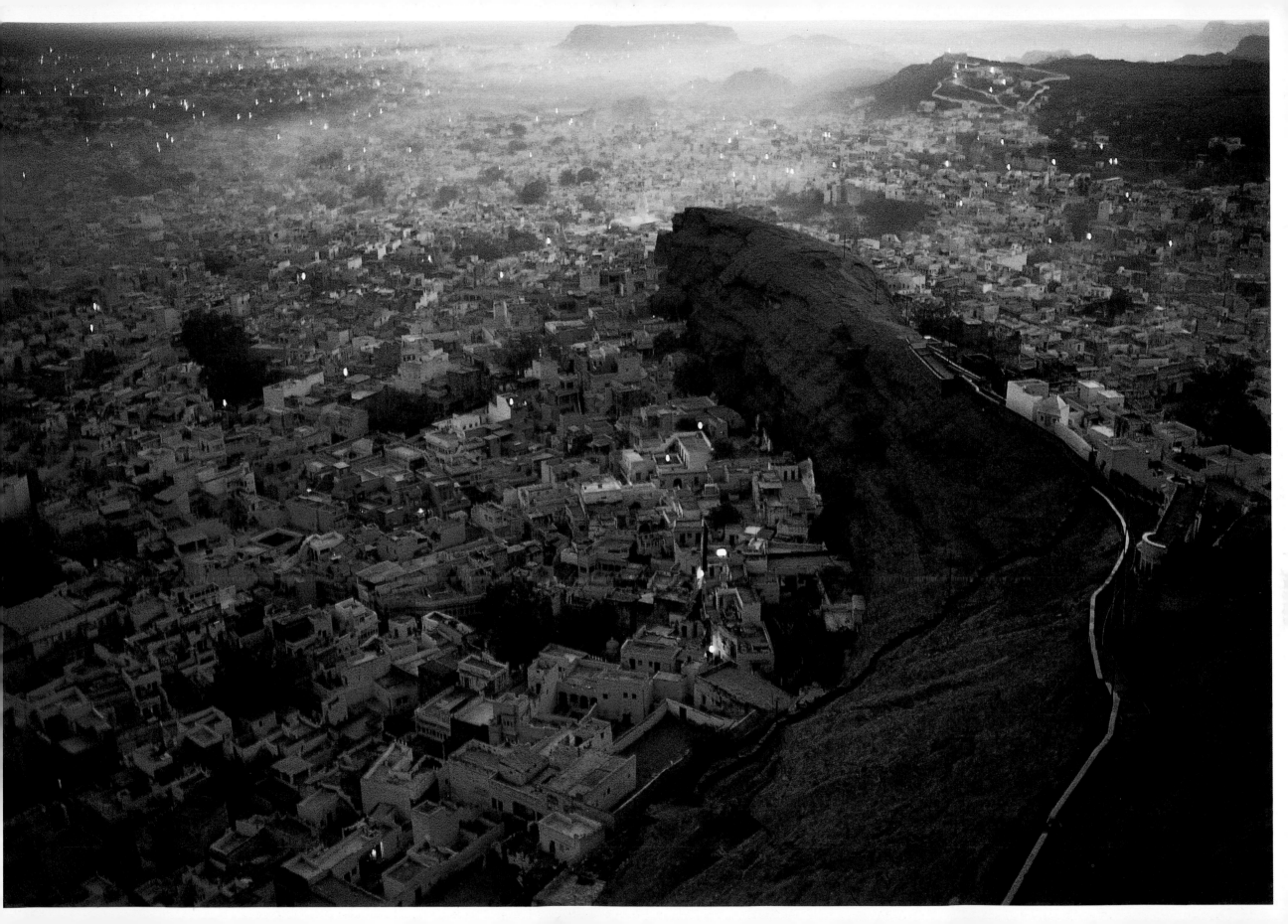

Two hundredth night

The Tale of
Kamar al-Zaman
and the Princess Budur,
Moon of Moons

I am the master of astrology,
The chief of wizardry,
The cord of blackest curtainry,
The supreme key of every treasury,
The pen by whose calligraphy
Black book and amulet come to be,
The hand which subtly
Spreads out the sands of prophecy
And draws electuary from written charactry;
Being talismanic energy
My word is victory. . . .
I am the chief of wizardry;
Come speedily,
I take not currency nor any other fee,
But work entirely for notoriety.

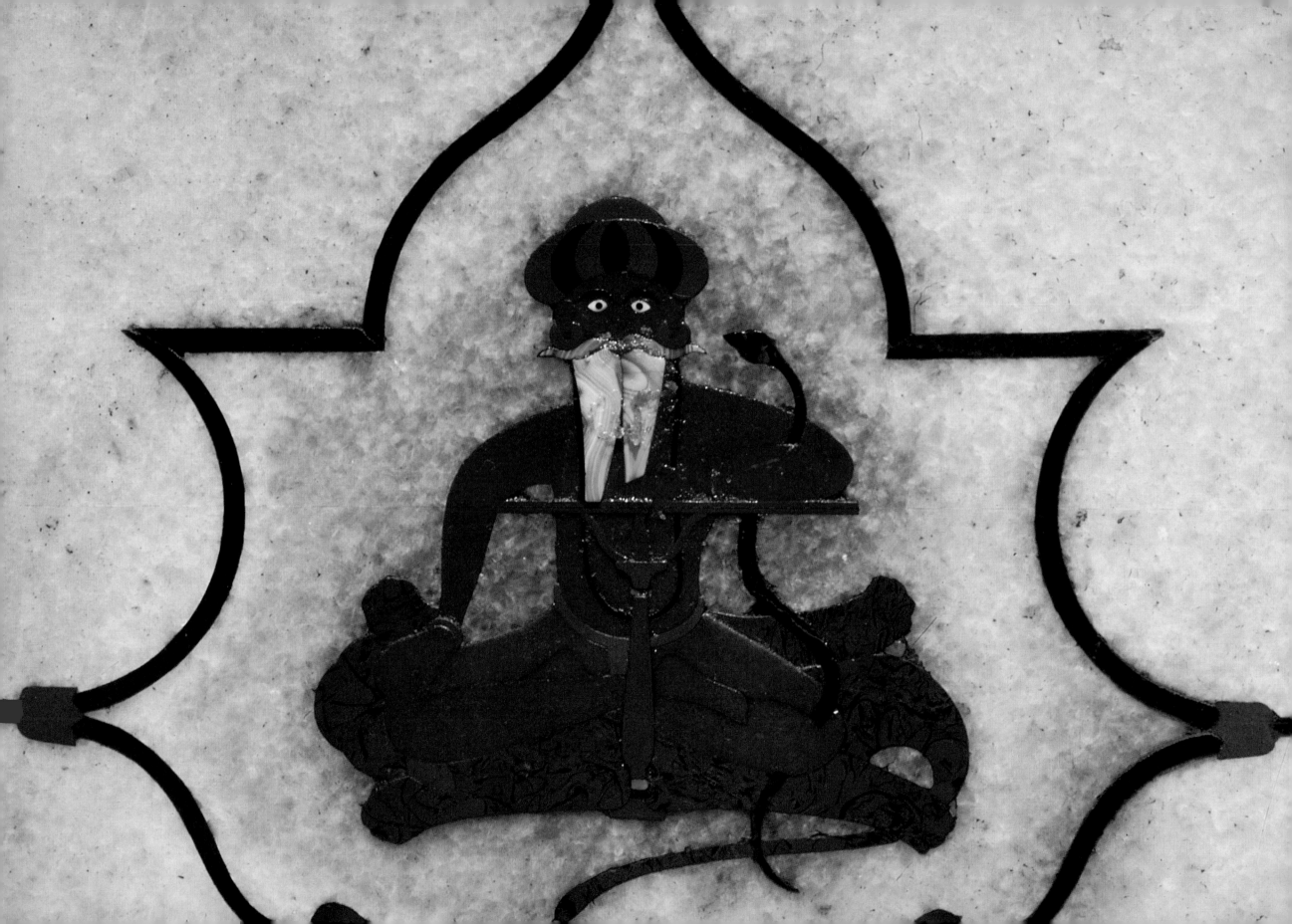

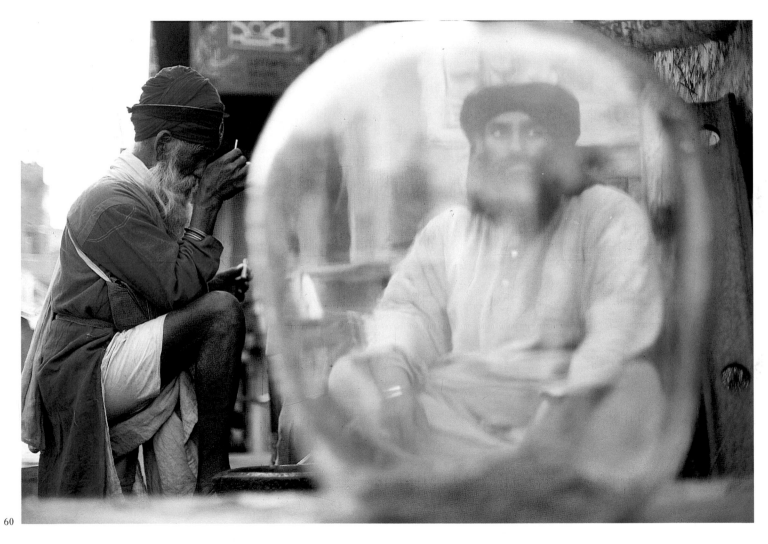

60

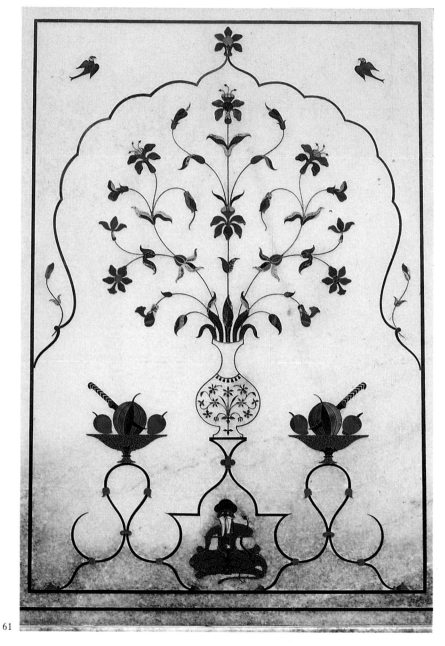

61

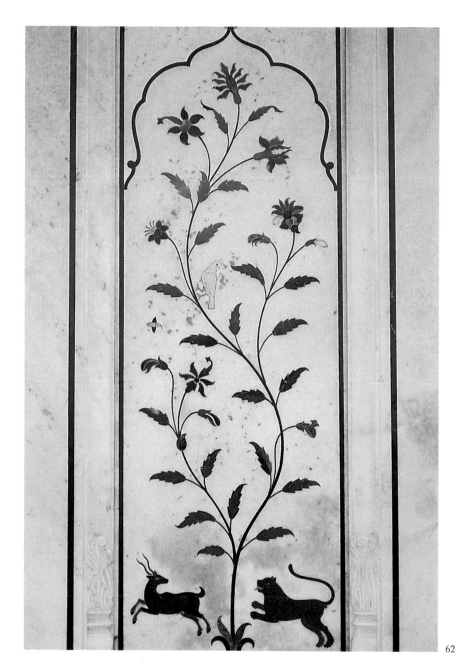

62

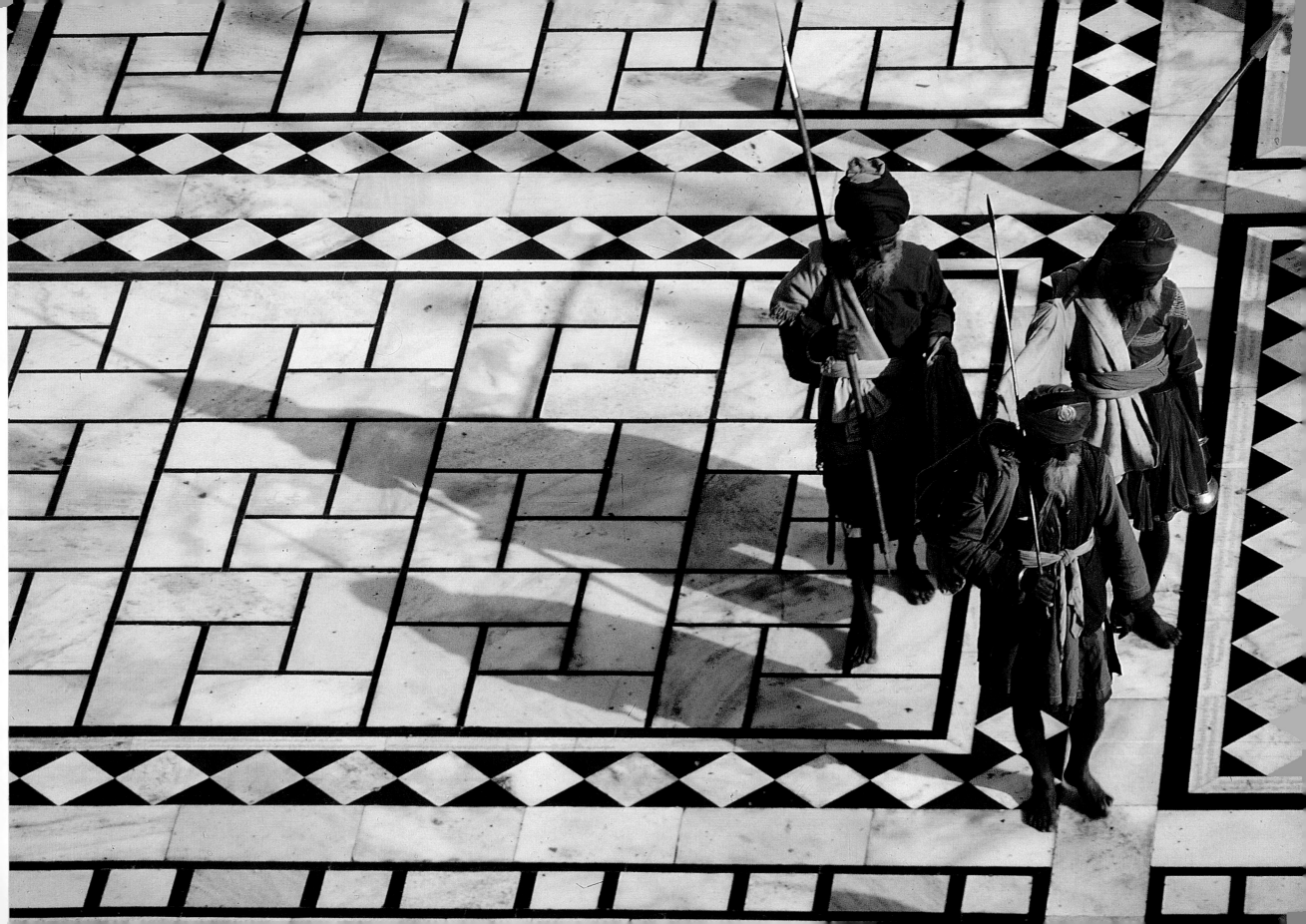

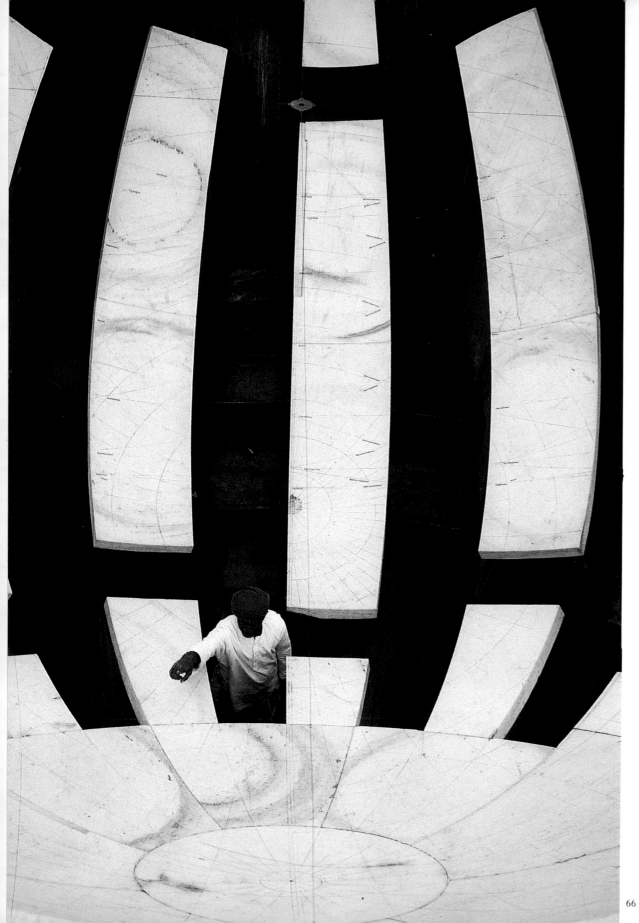

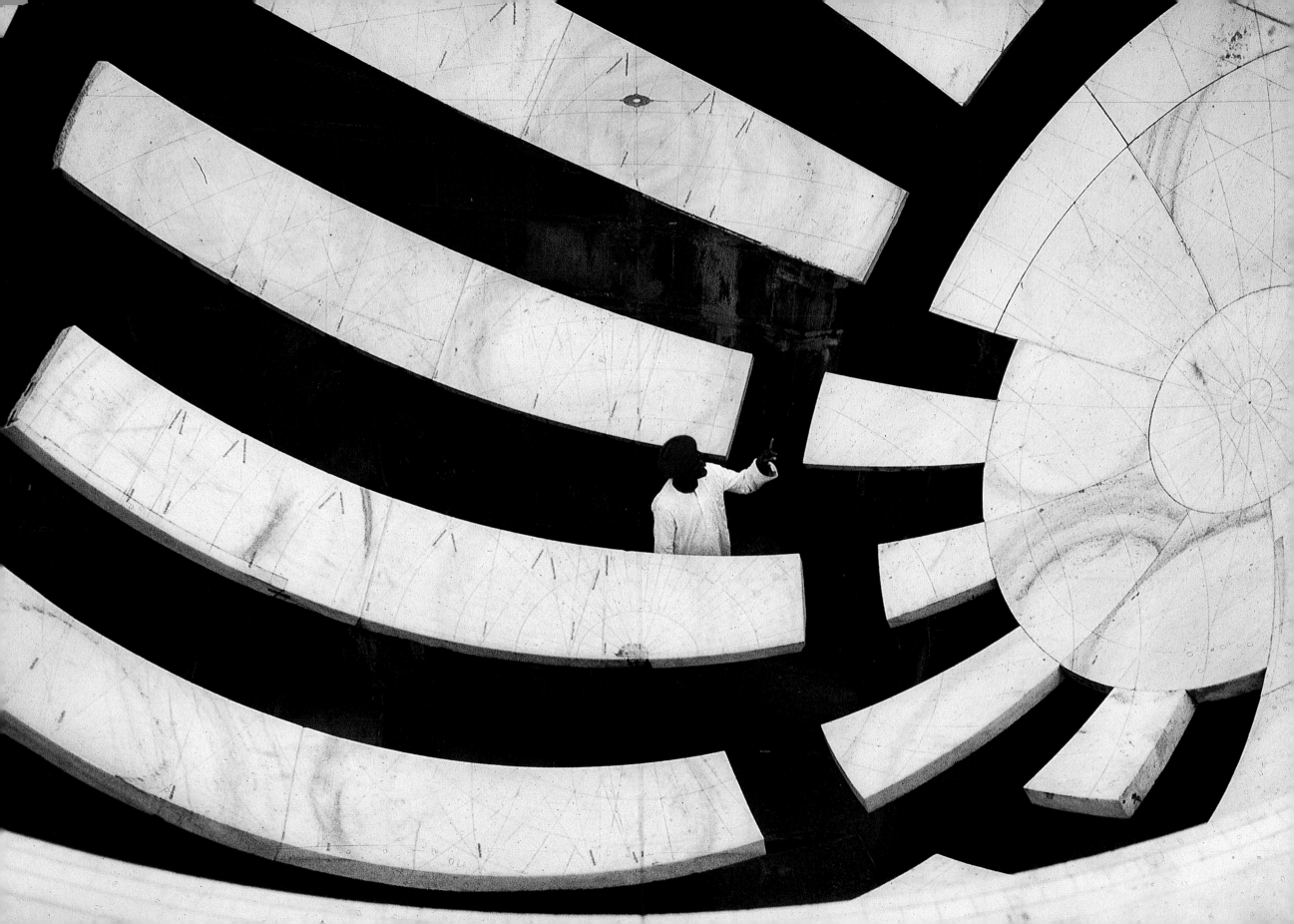

Eight hundred and eighth night

The Tale of
Princess Nur al-Nihar
and the Lovely Jinniyah

T
hen a thousand elephants advanced. . . . The trunks and ears of these elephants were painted with vermilion and cinnabar, their tusks were gilt all over, and their bodies were tinted in bright colors with a grotesque contortion of whirling arms and legs.

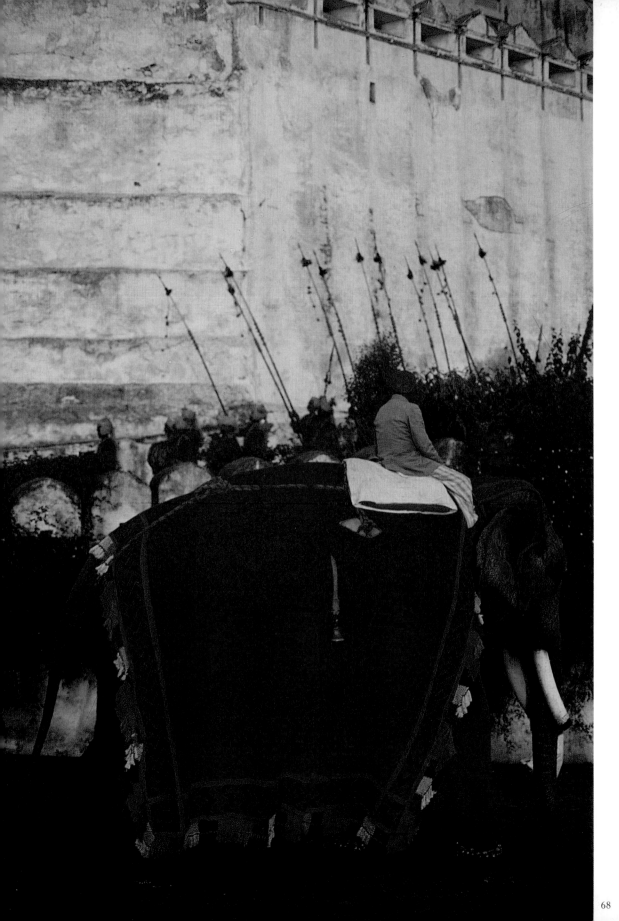

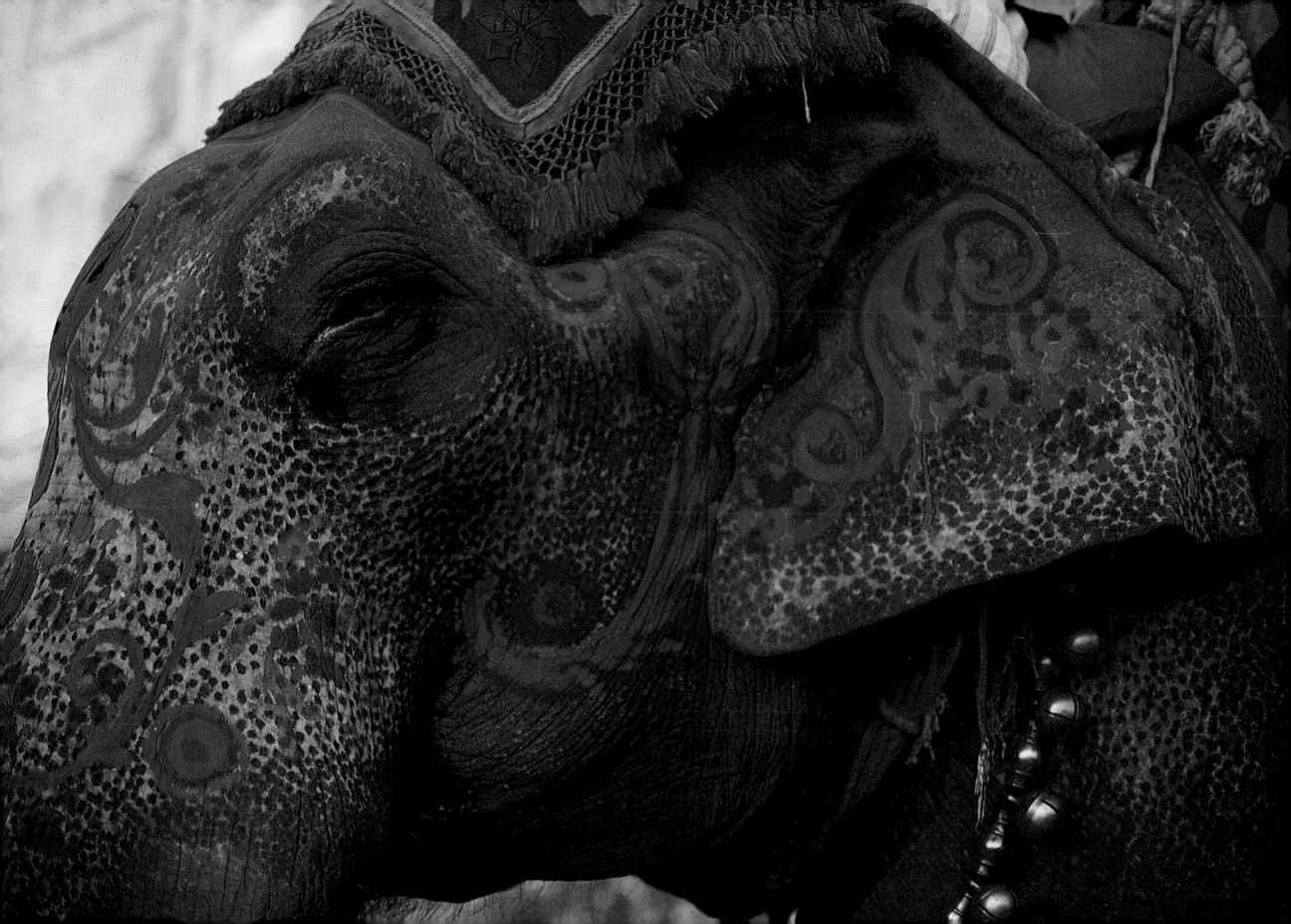

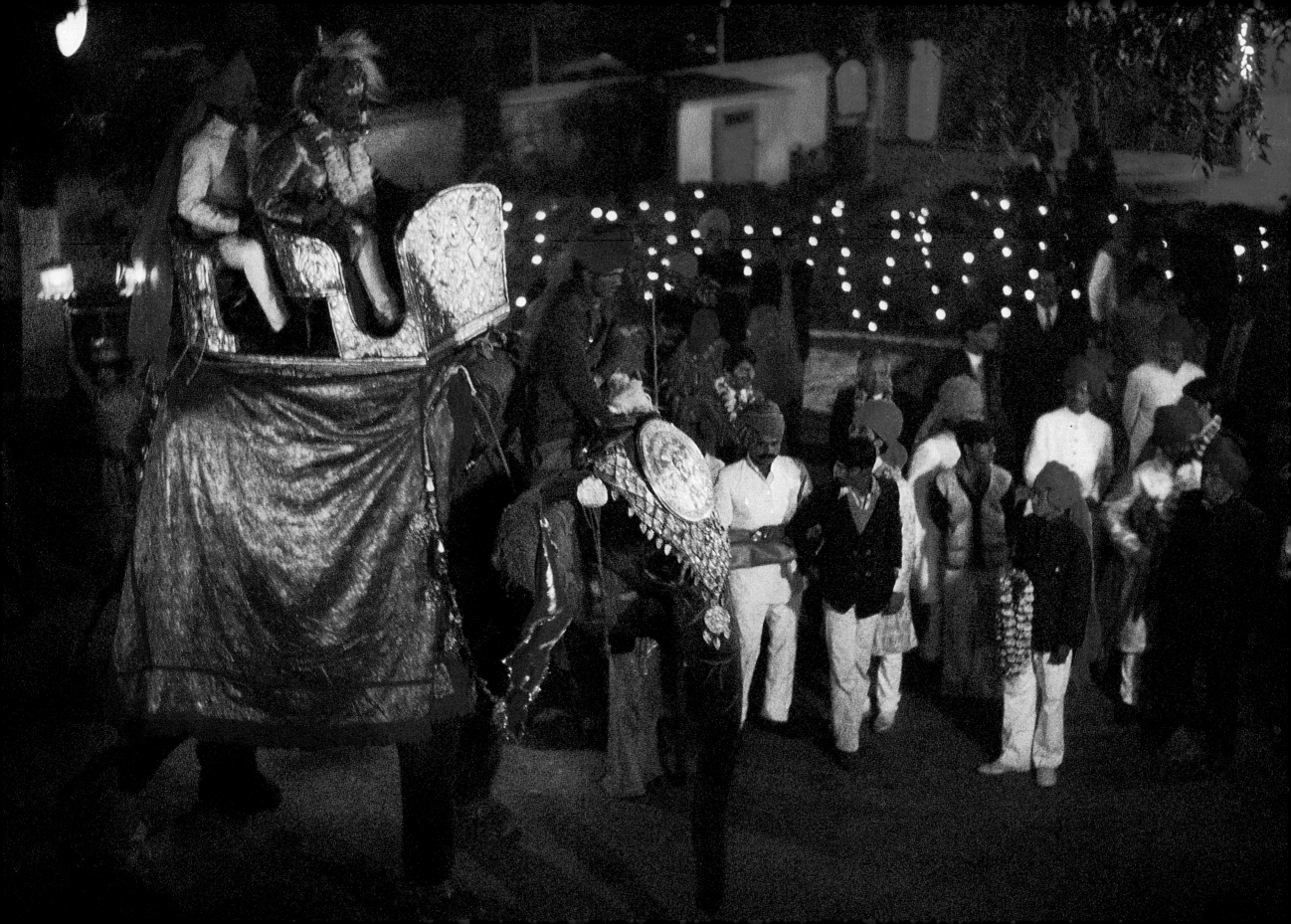

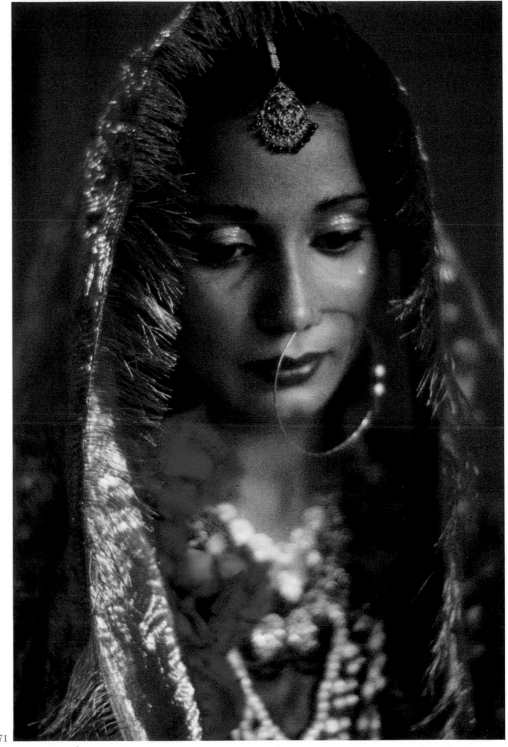

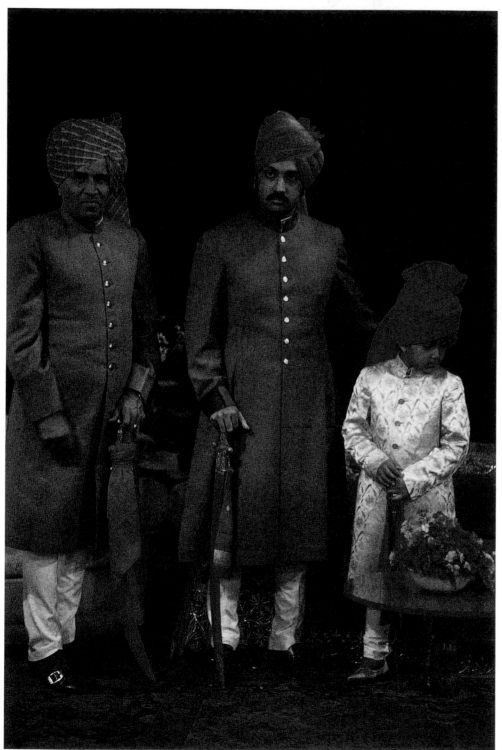

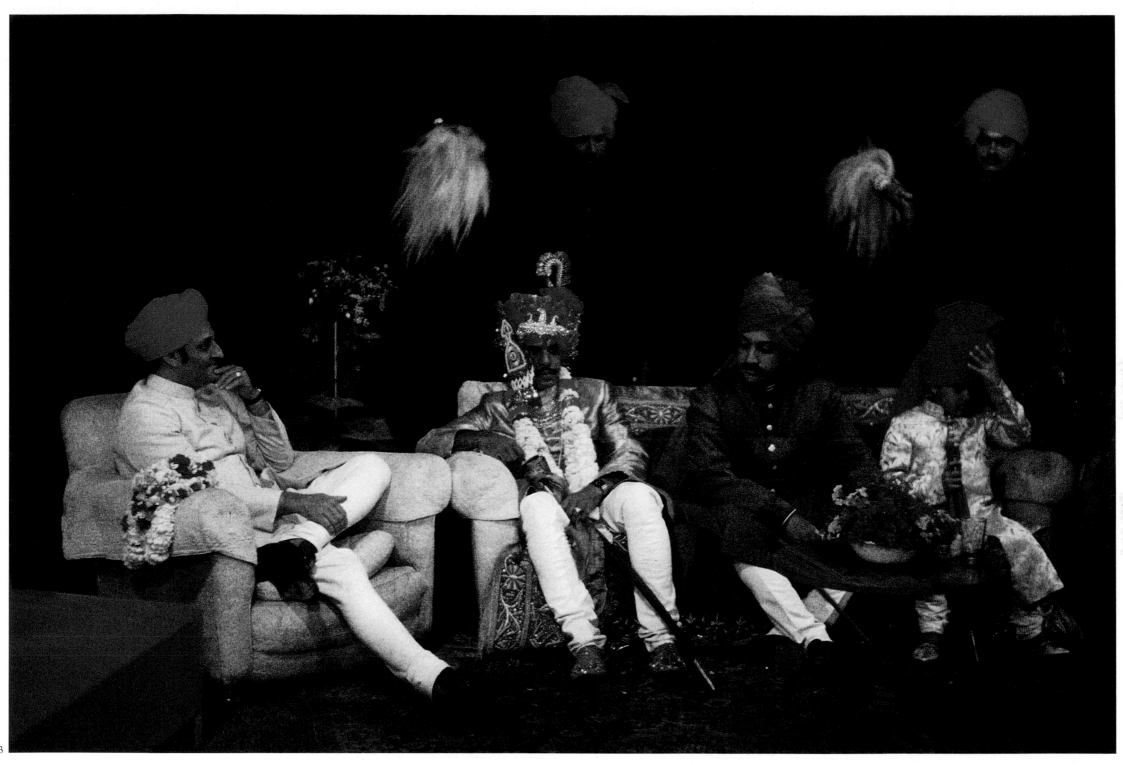

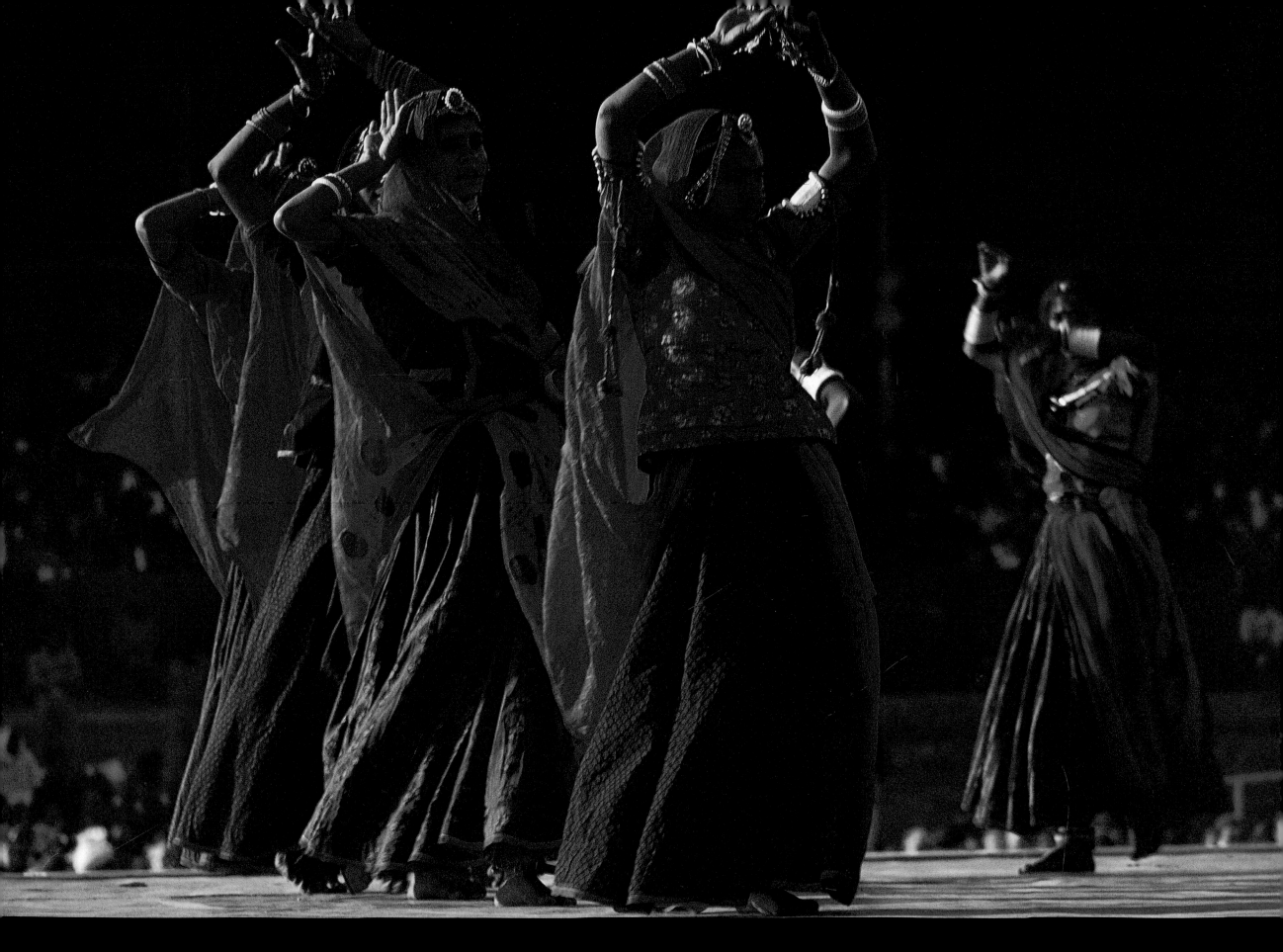

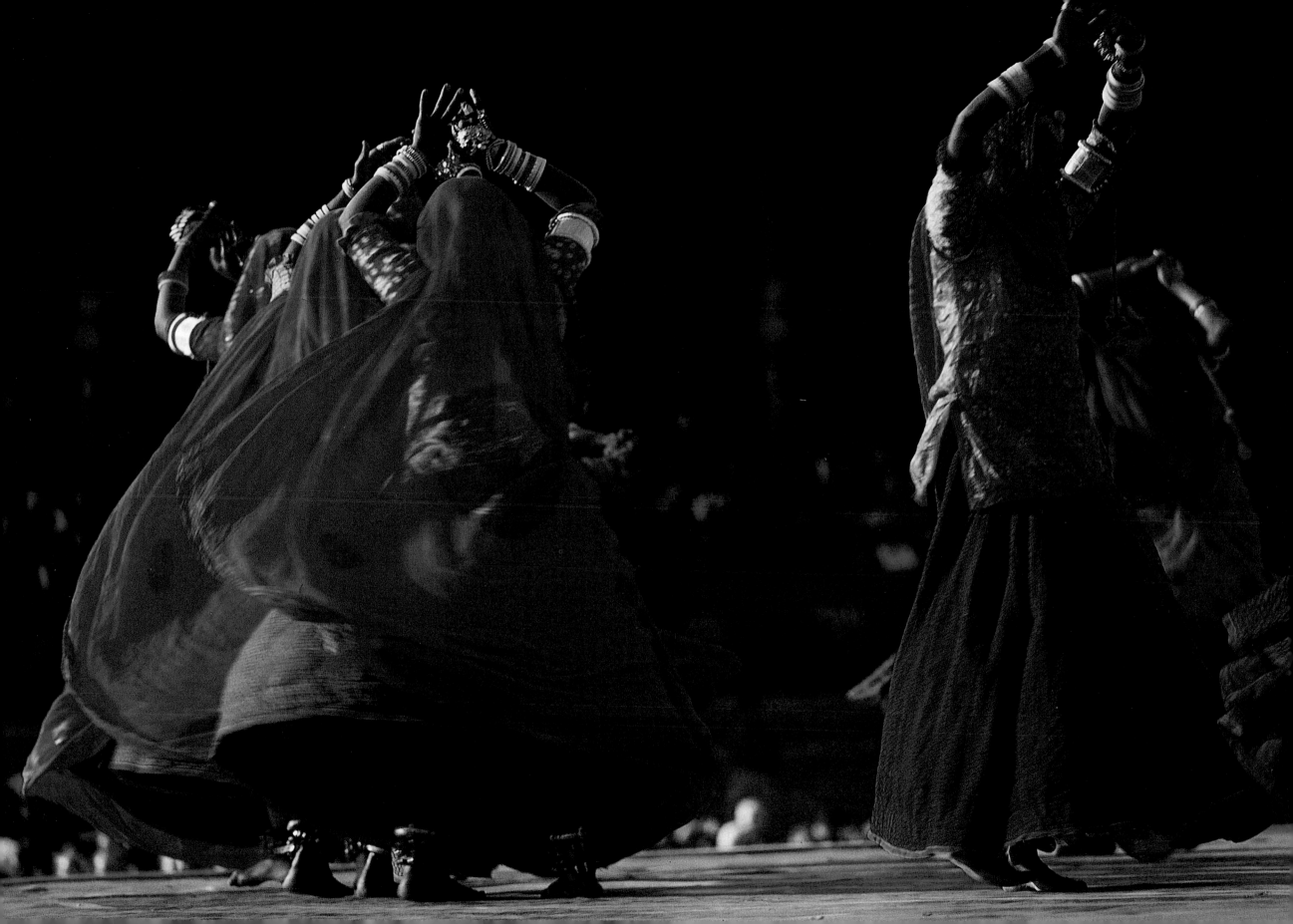

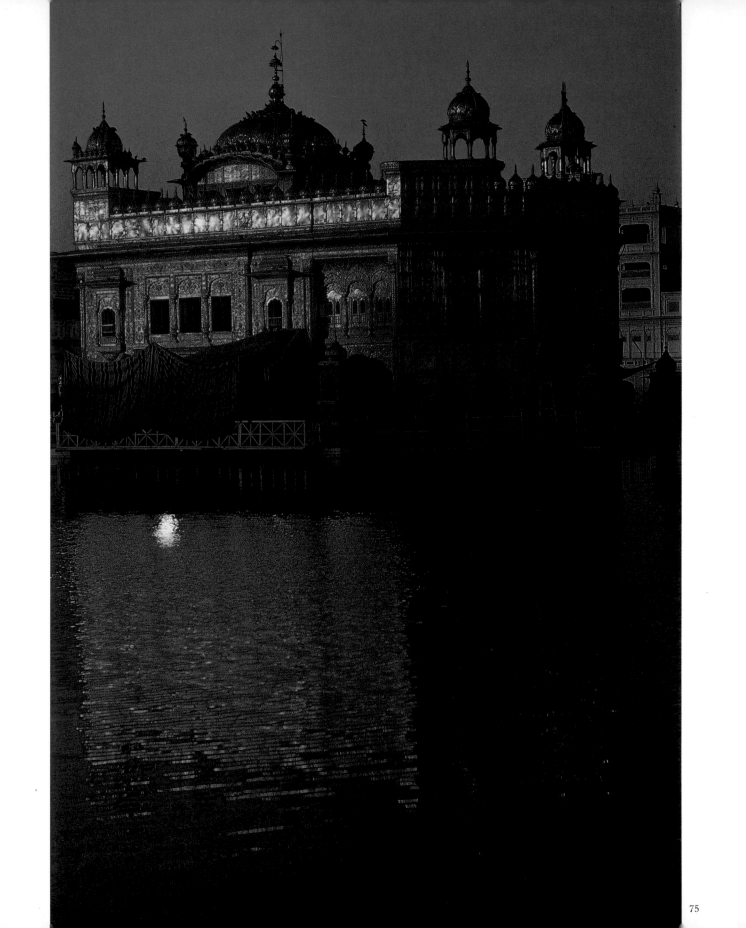

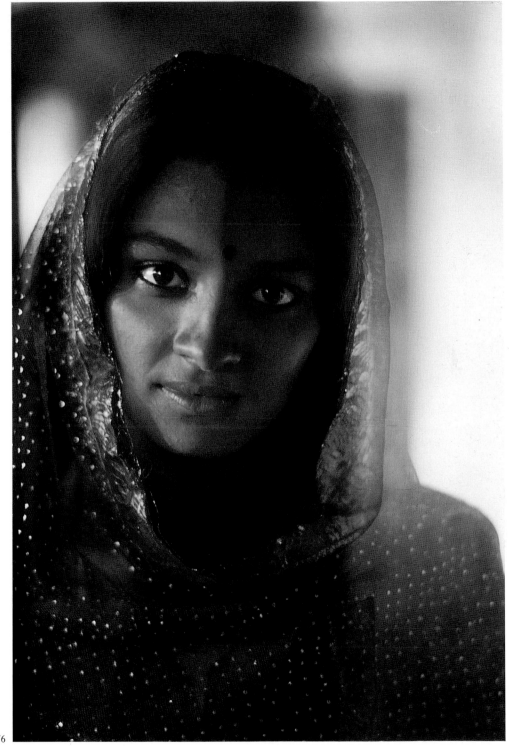

Twenty-first night

The Tale of the Wazir Nur al-Din, his Brother the Wazir Shams al-Din, and Hasan Badr al-Din

She was scented with musk, with amber, with roses; her delicately combed hair shone under silk. . . .

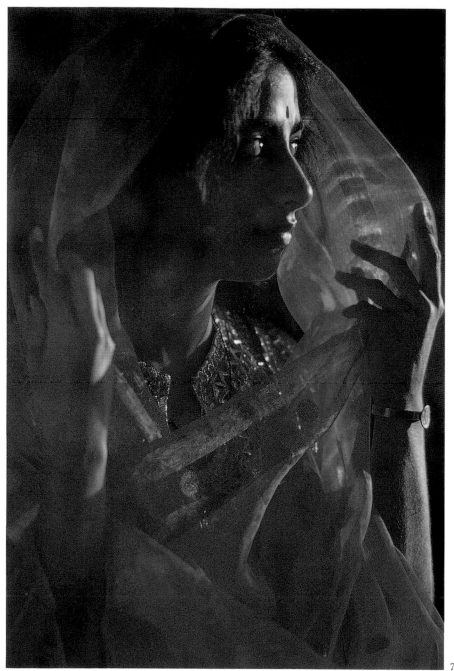

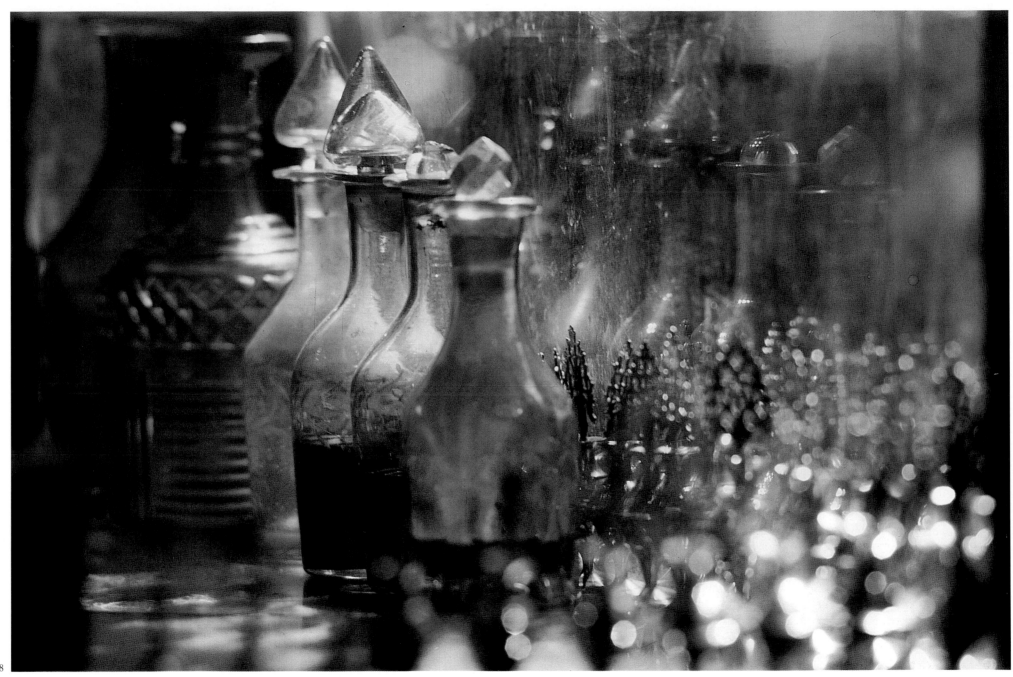

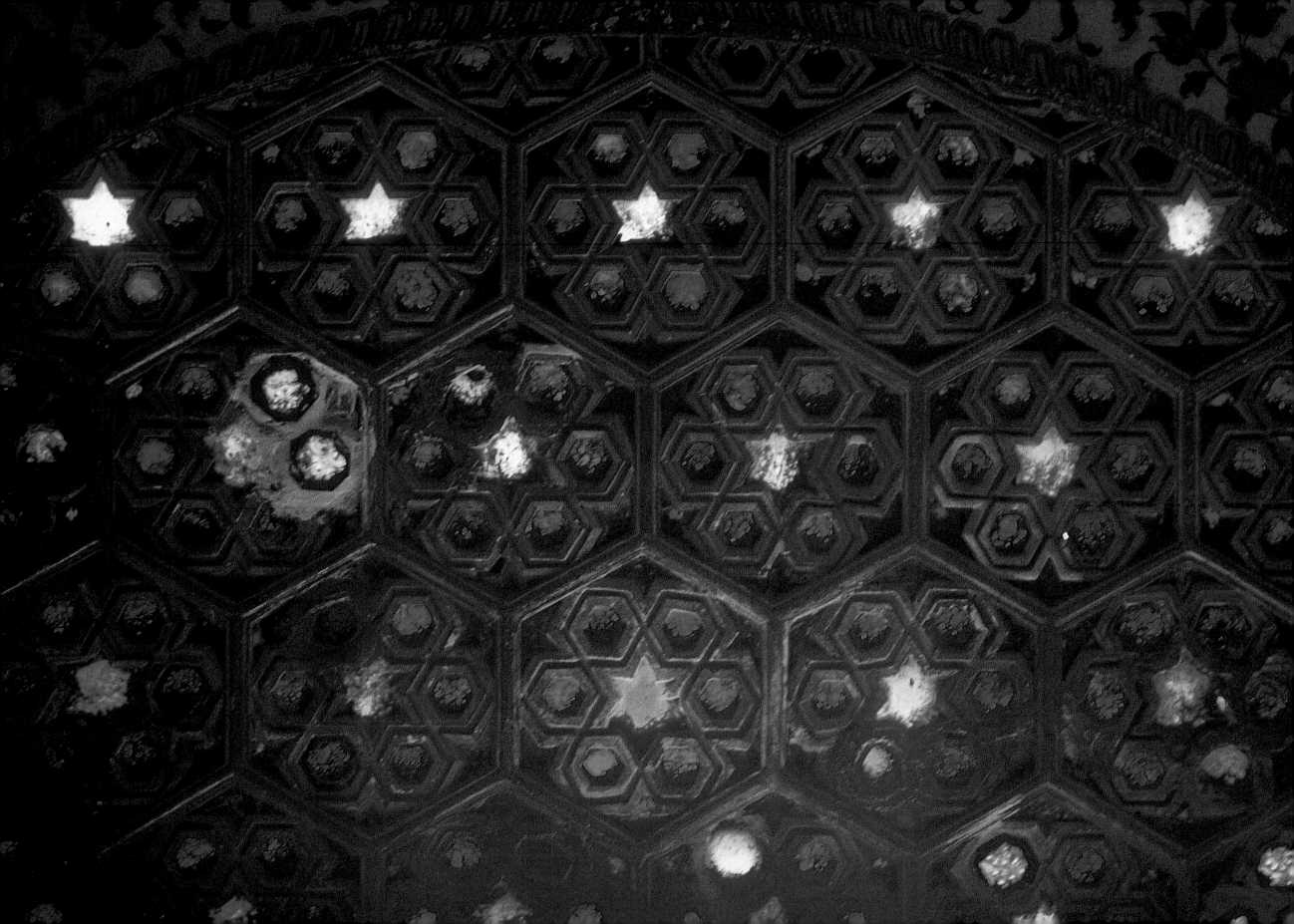

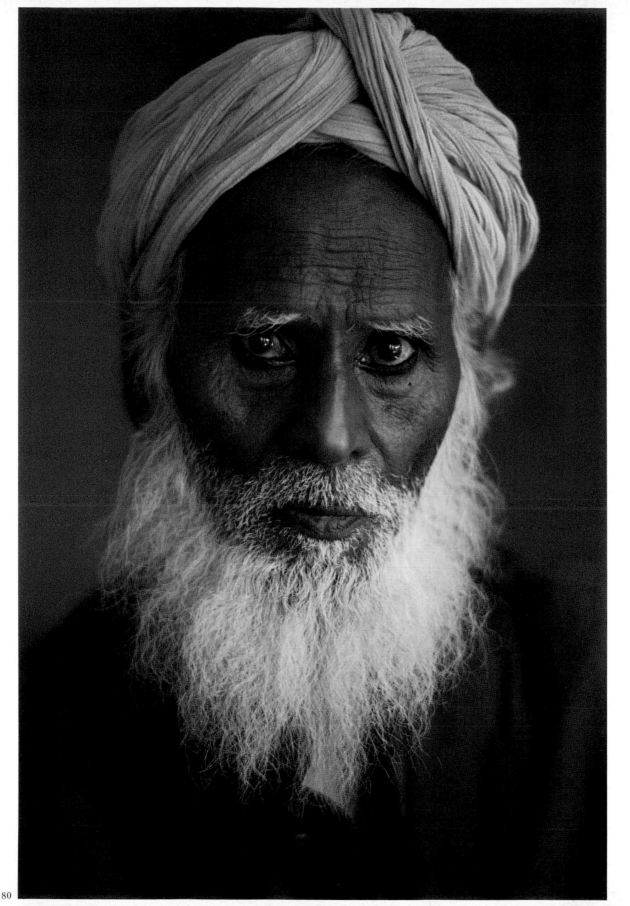

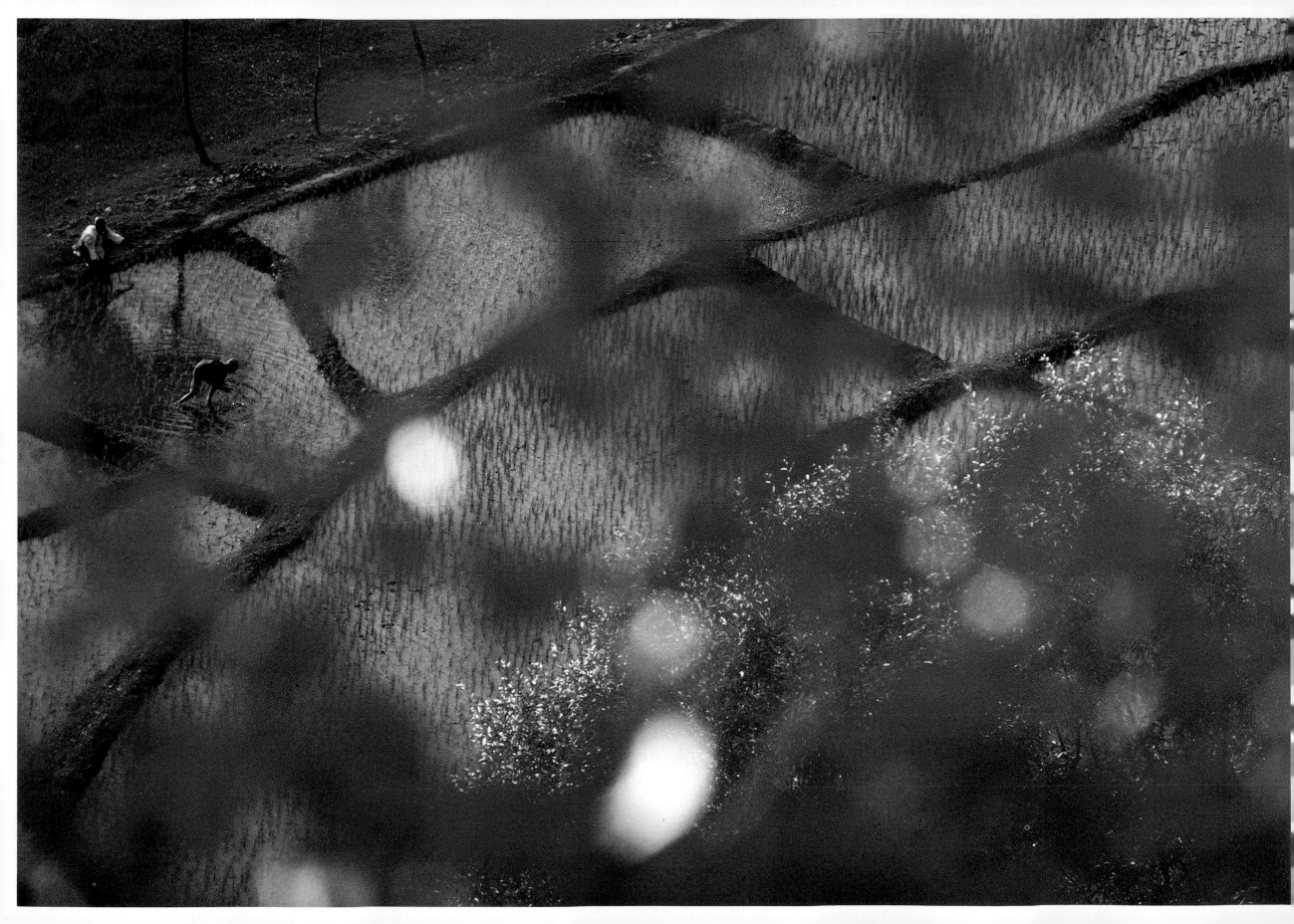

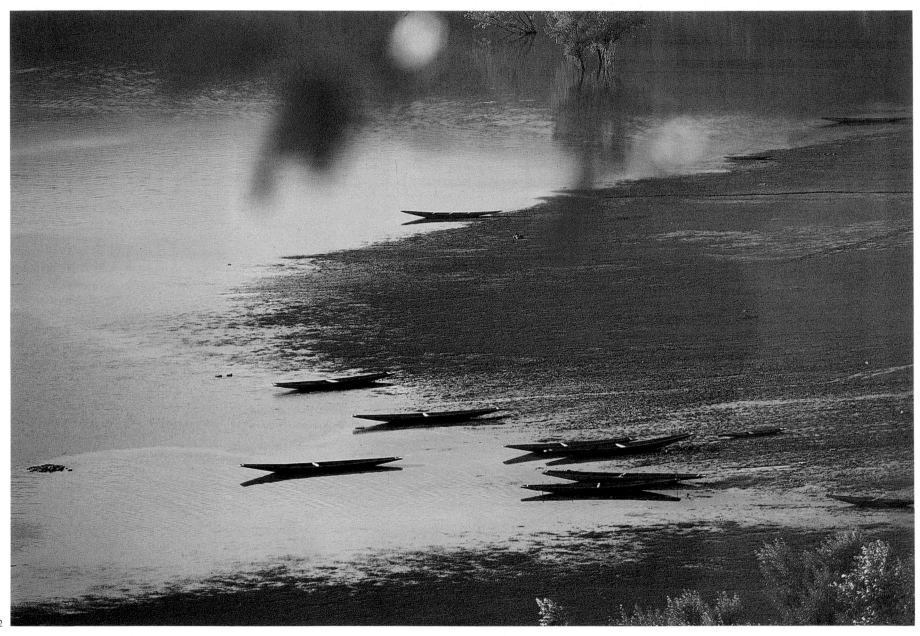

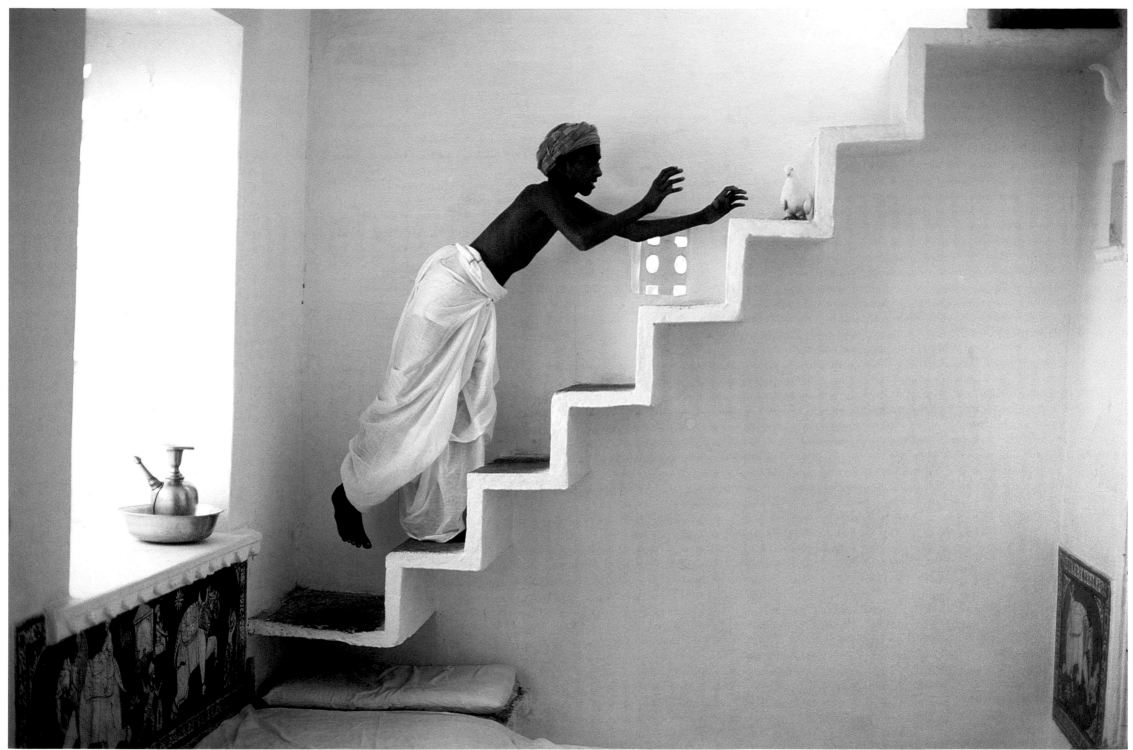

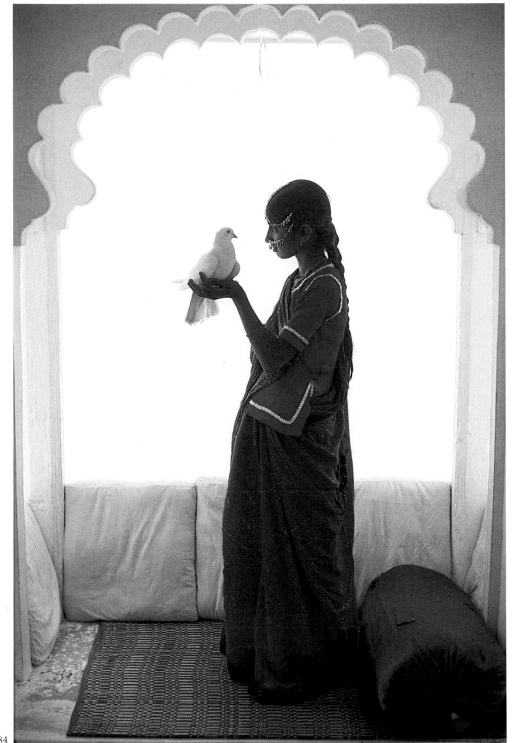

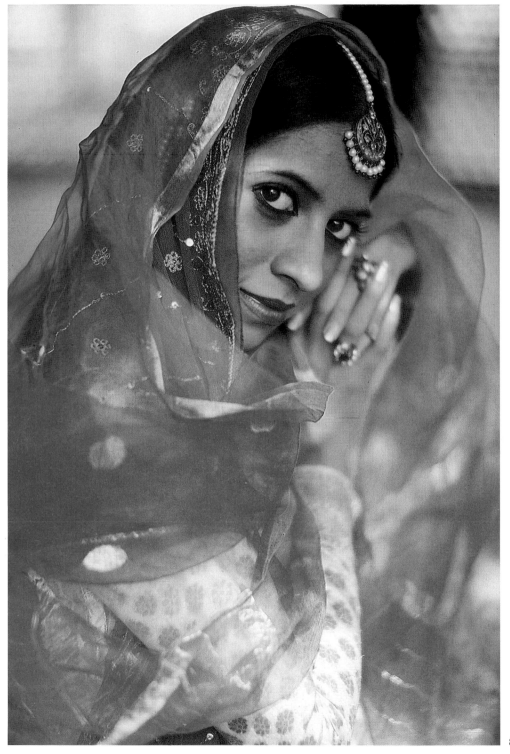

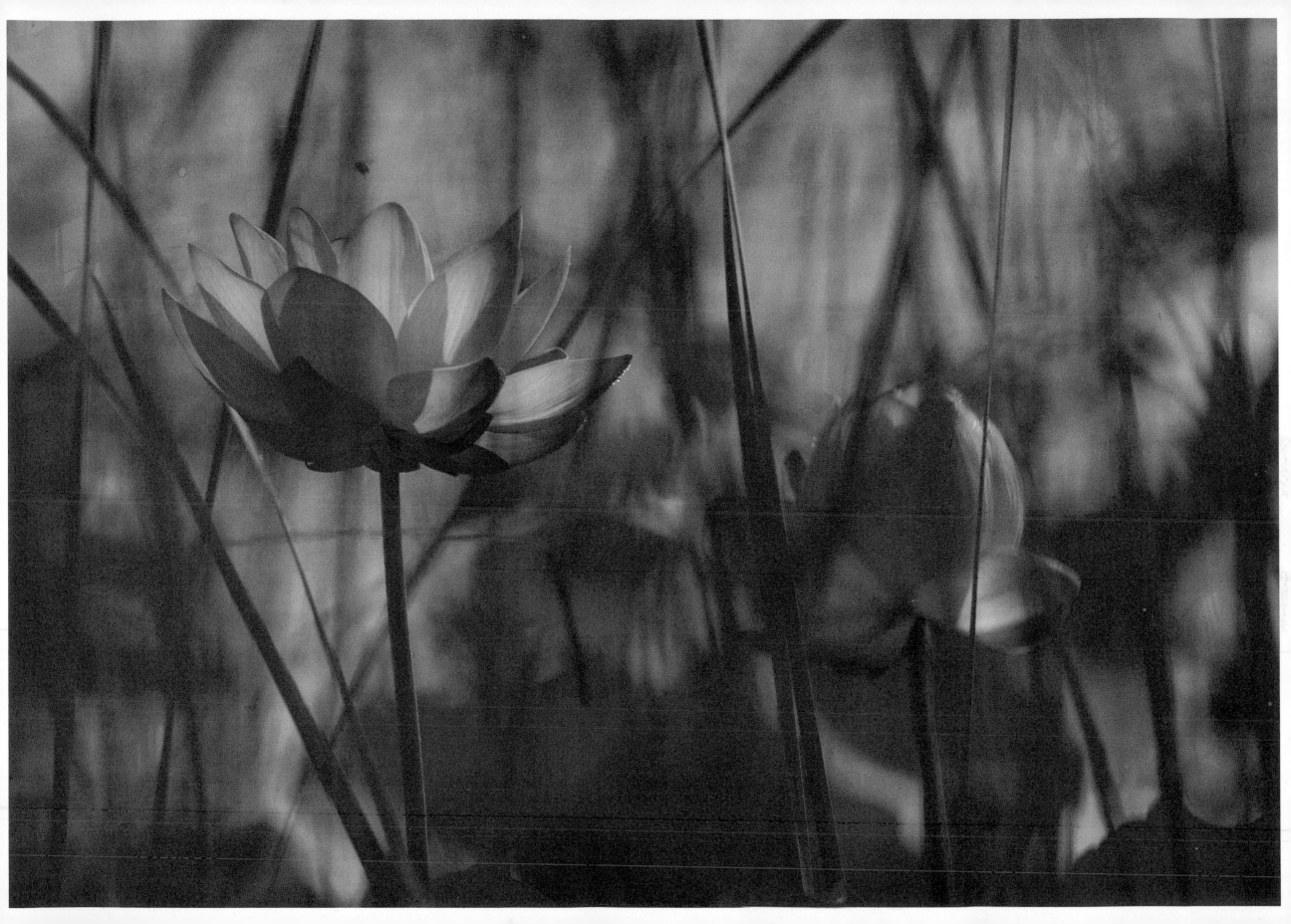

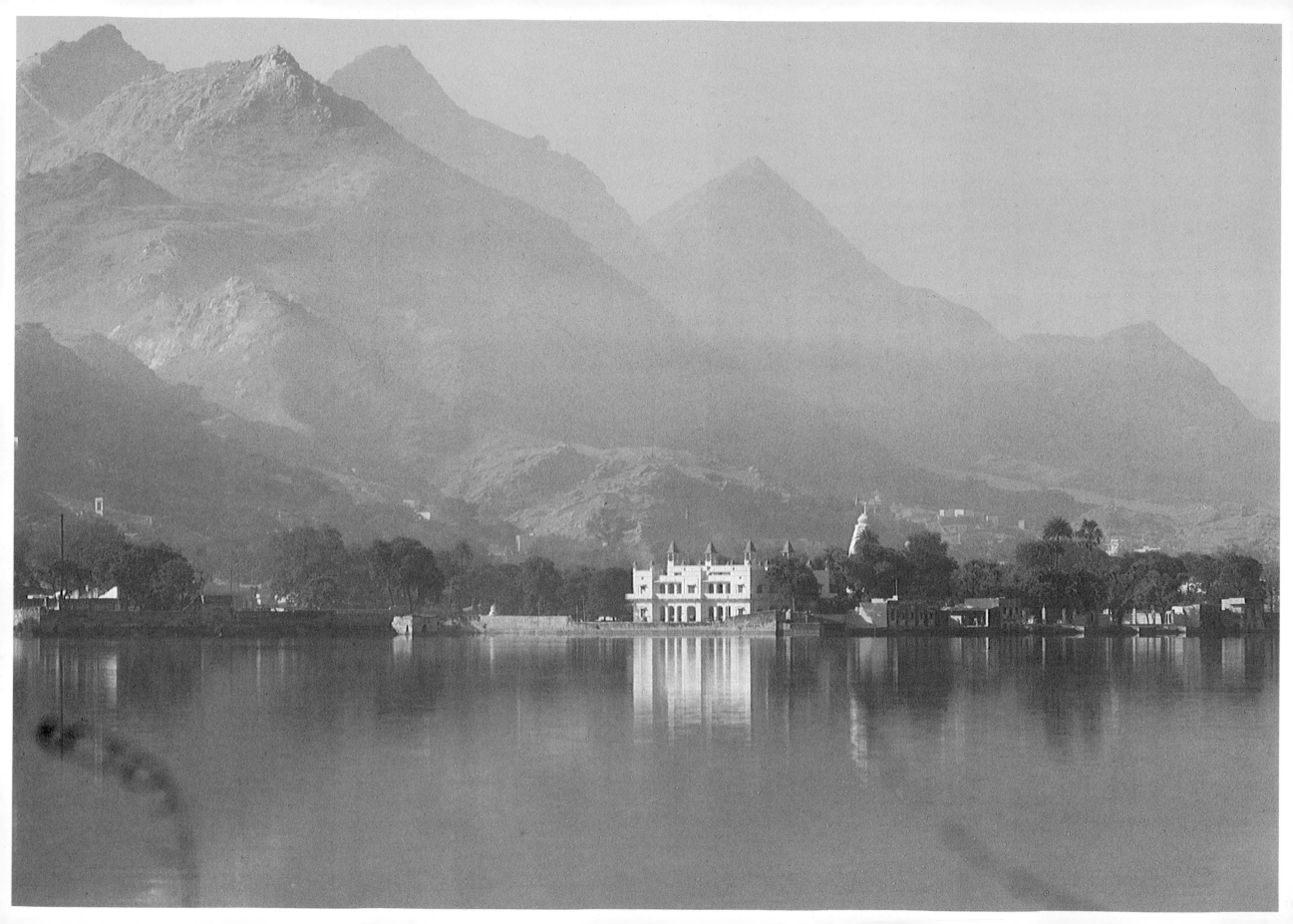

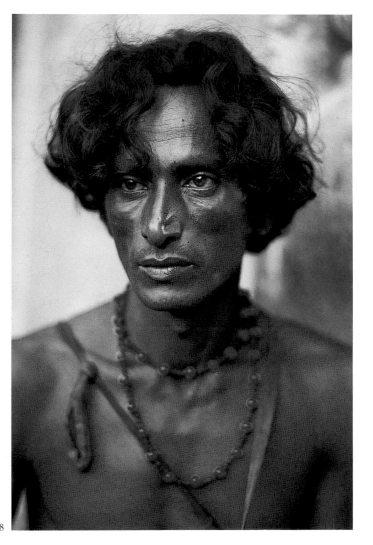

88

Seven hundred and sixtieth night

The Tale of Aladdin
and the Wonderful Lamp

I wish you to build me, with the least possible delay, a palace worthy of my bride, on the open ground in front of the Sultan's dwelling. I leave to your good taste and proven knowledge the details of its ornament and the choice of such precious material as jade, porphyry, alabaster, agate, lazuli, jasper, marble and granite.

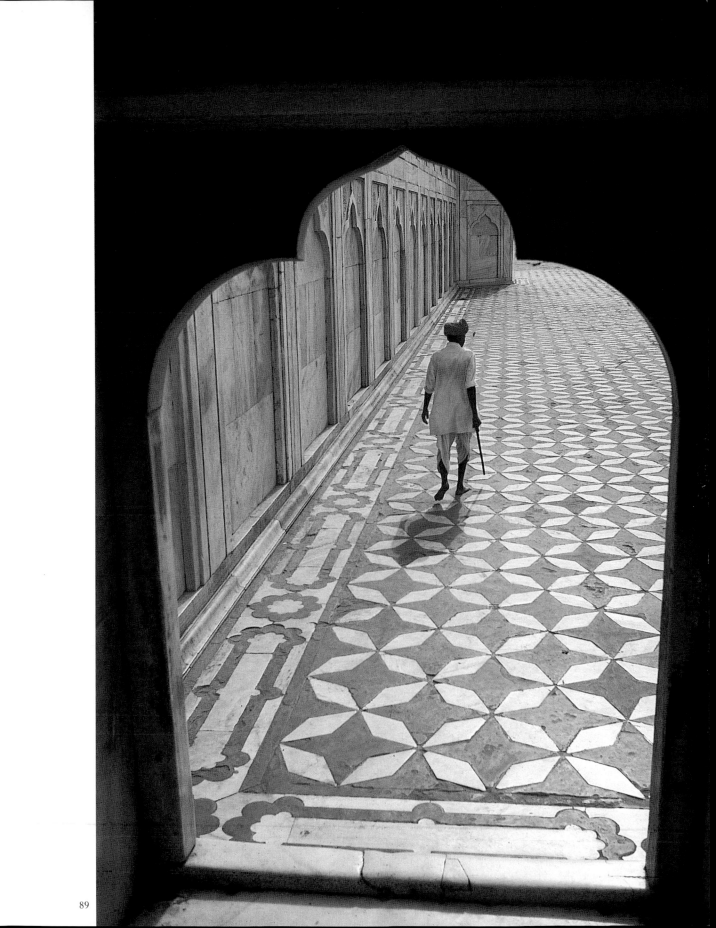

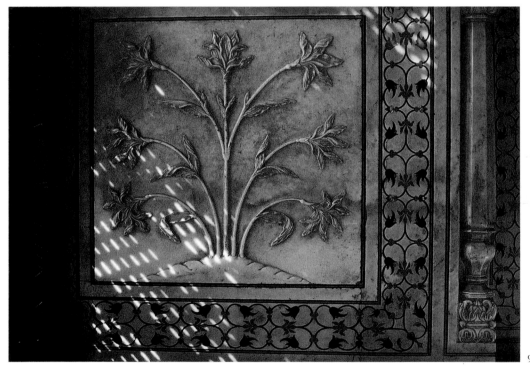

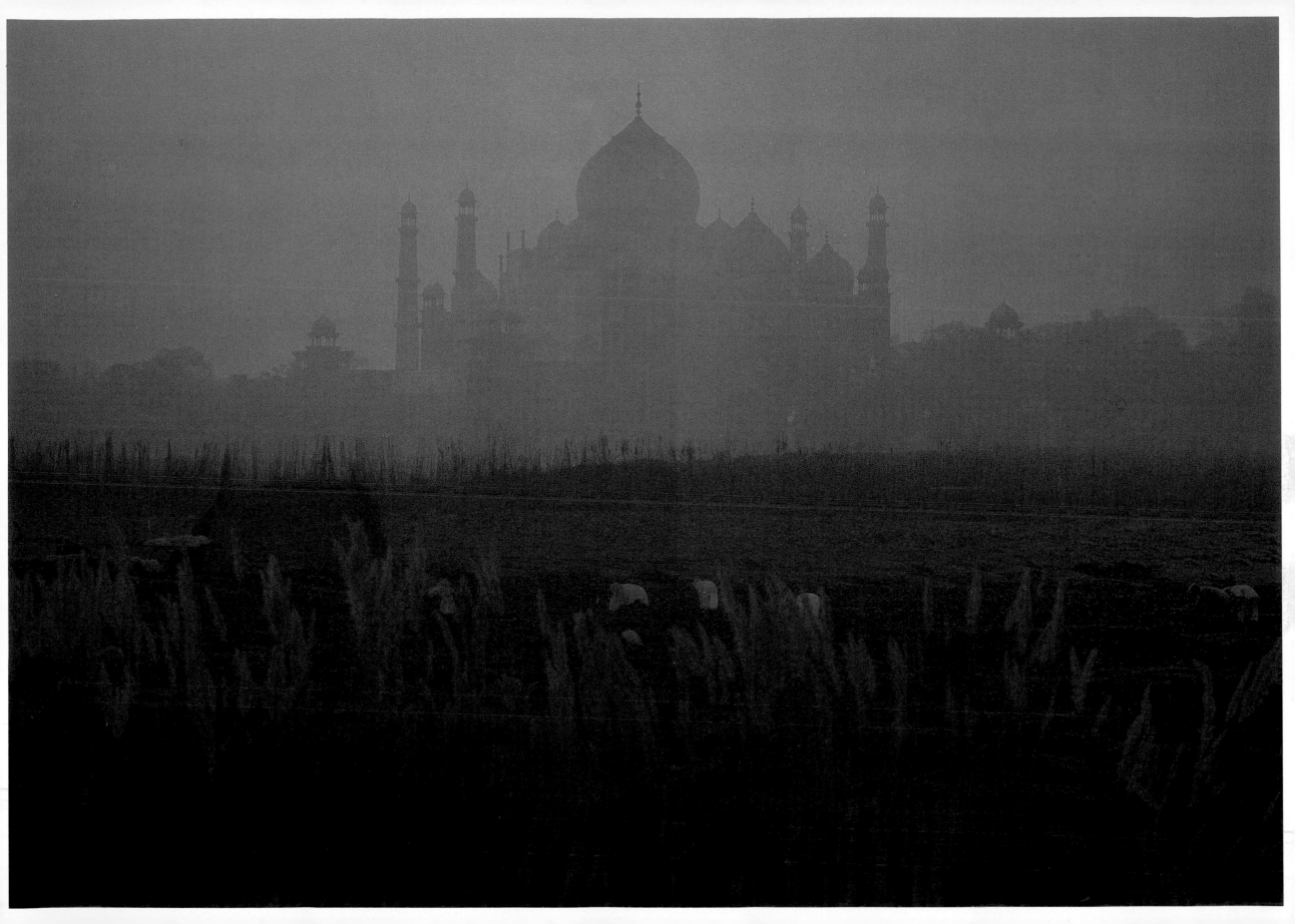

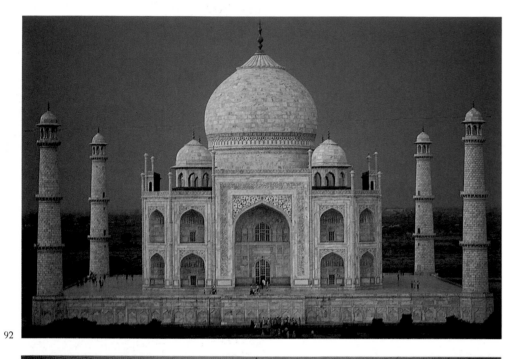

92

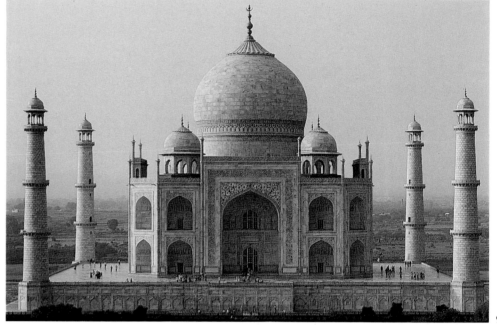

93

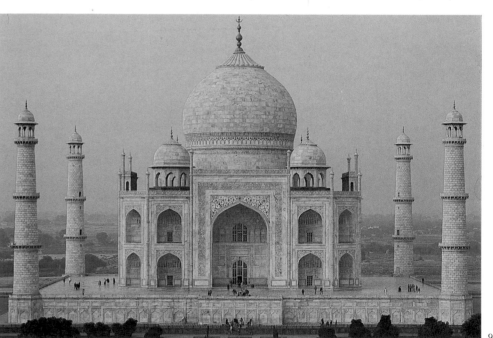

94

95

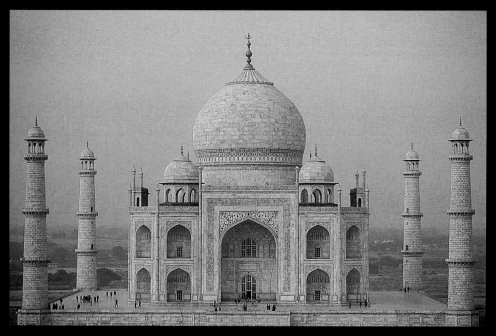

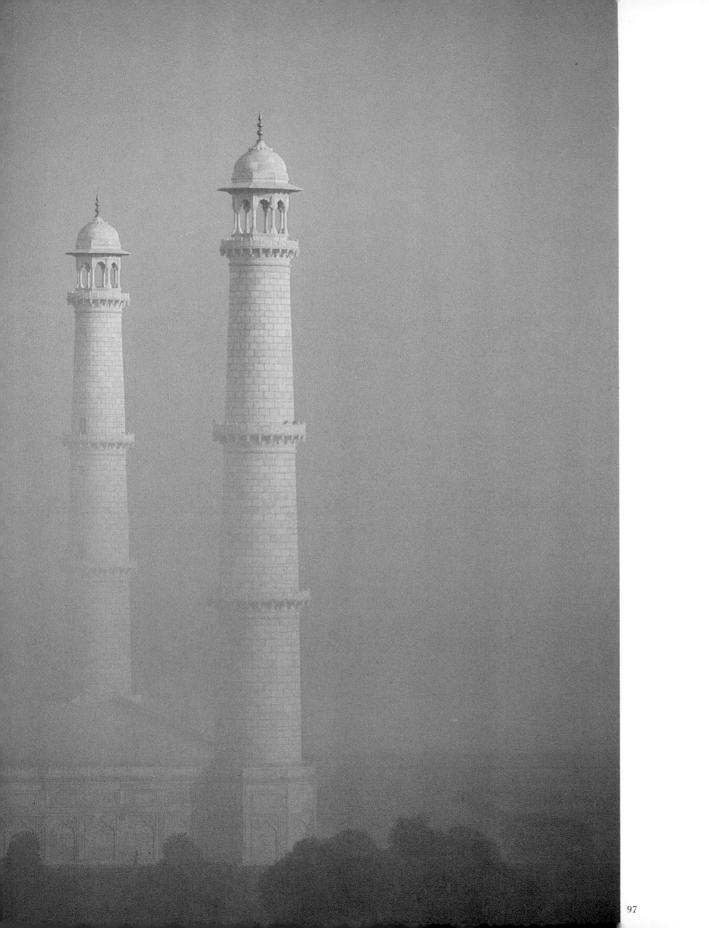

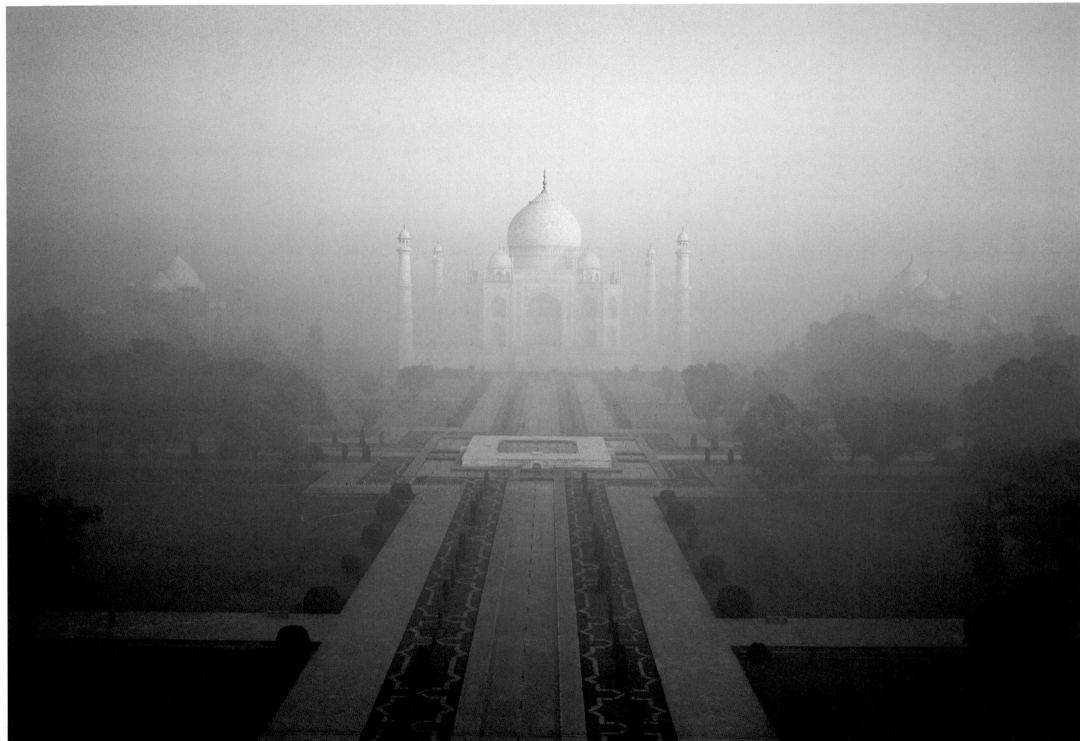

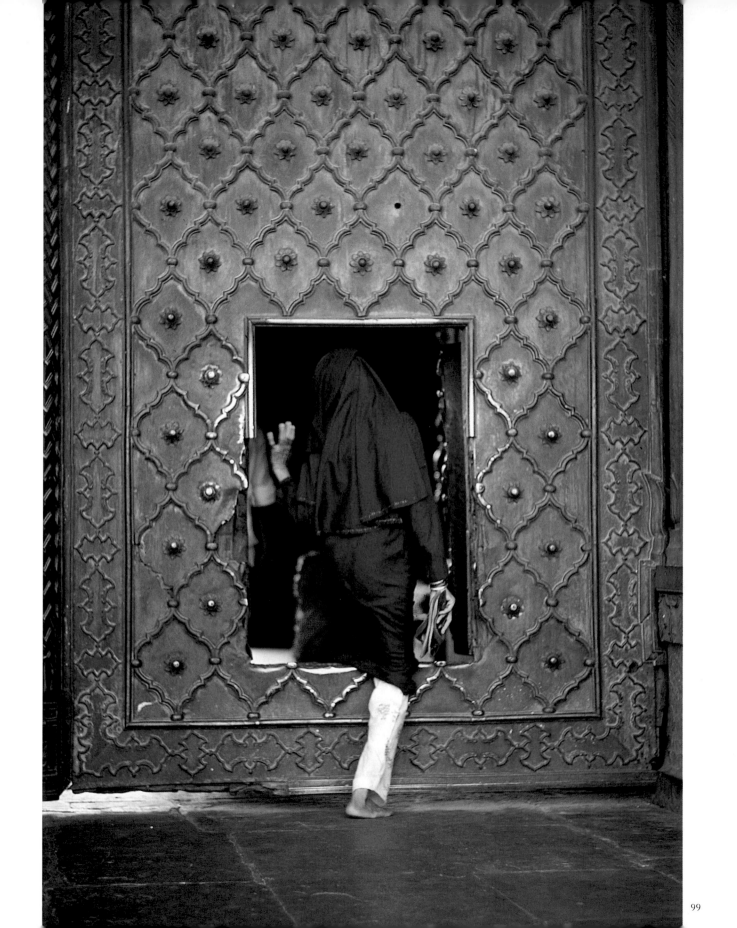

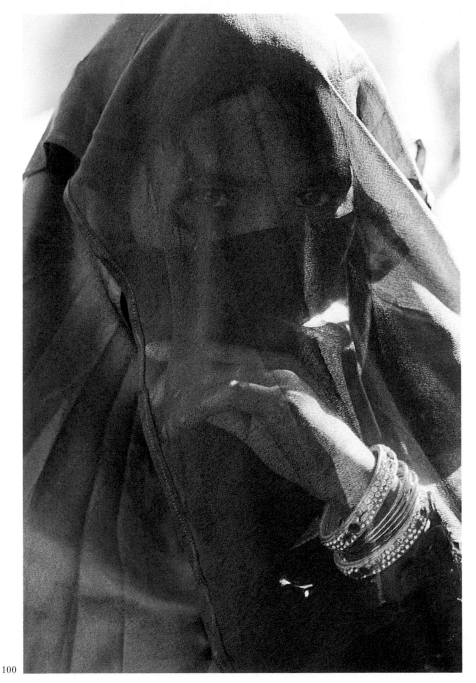

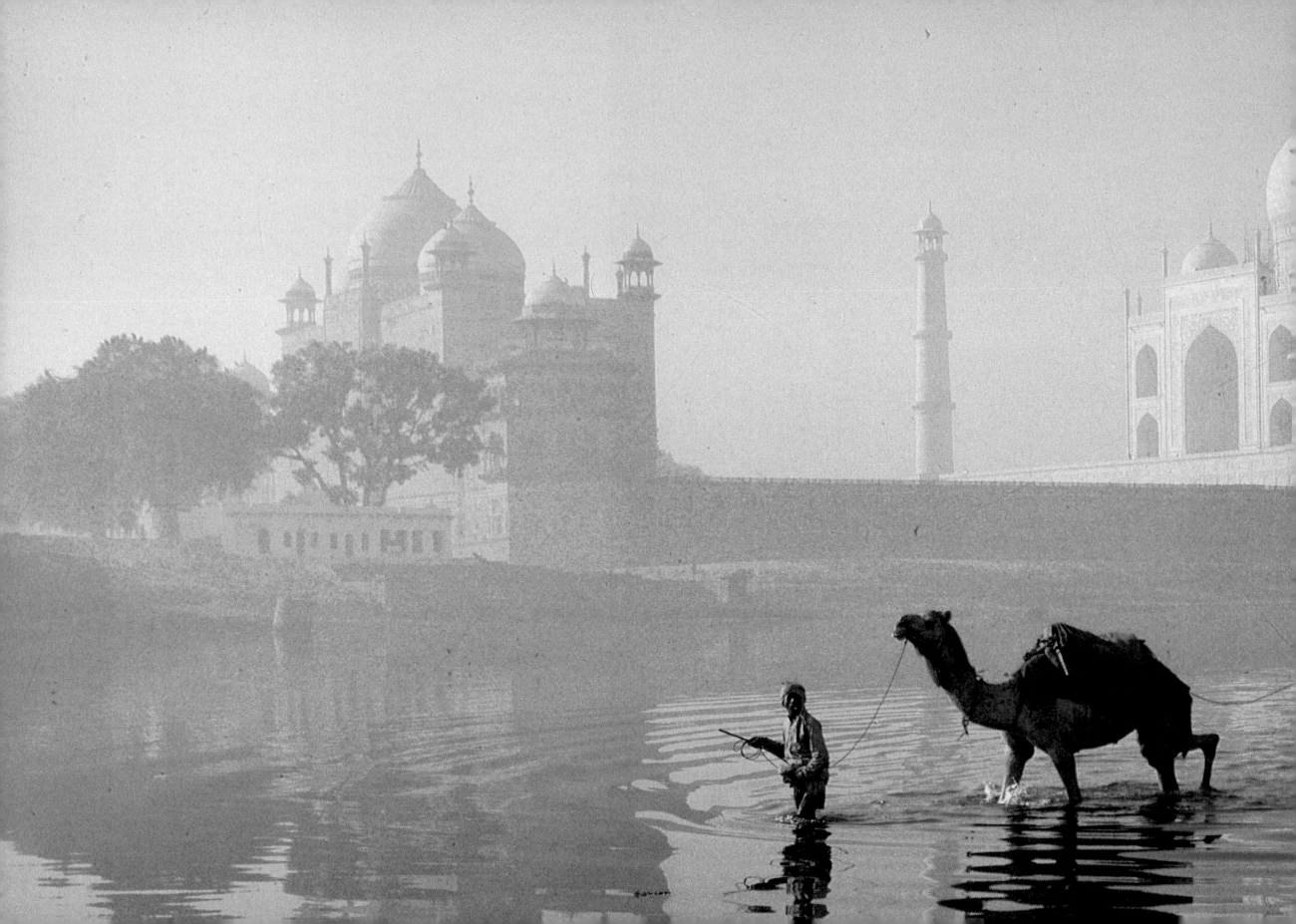

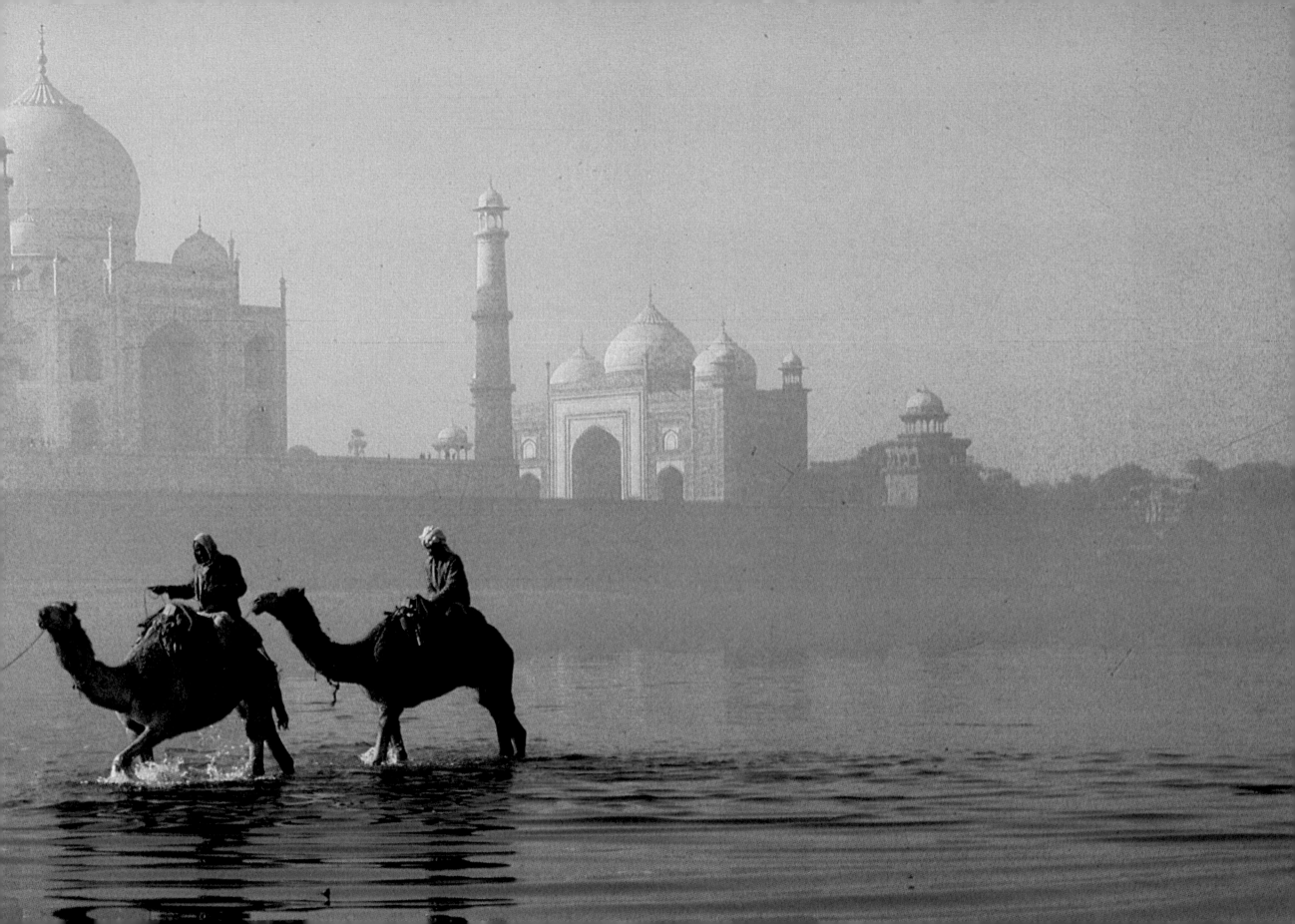

Two hundred and sixth night

The Tale of Kamar al-Zaman and the Princess Budur, Moon of Moons

From time to time the breeze lifted the filmy chemise to her navel, showing her belly, which was as white as snow, with dimples in delicate places, each large enough to hold an ounce of powdered nutmeg.

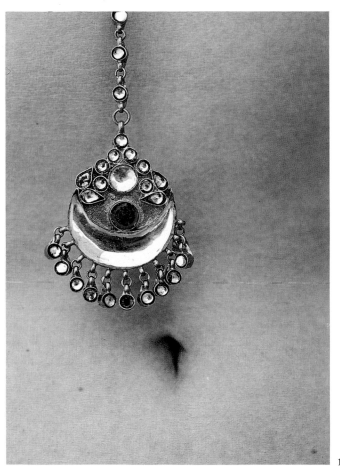

102

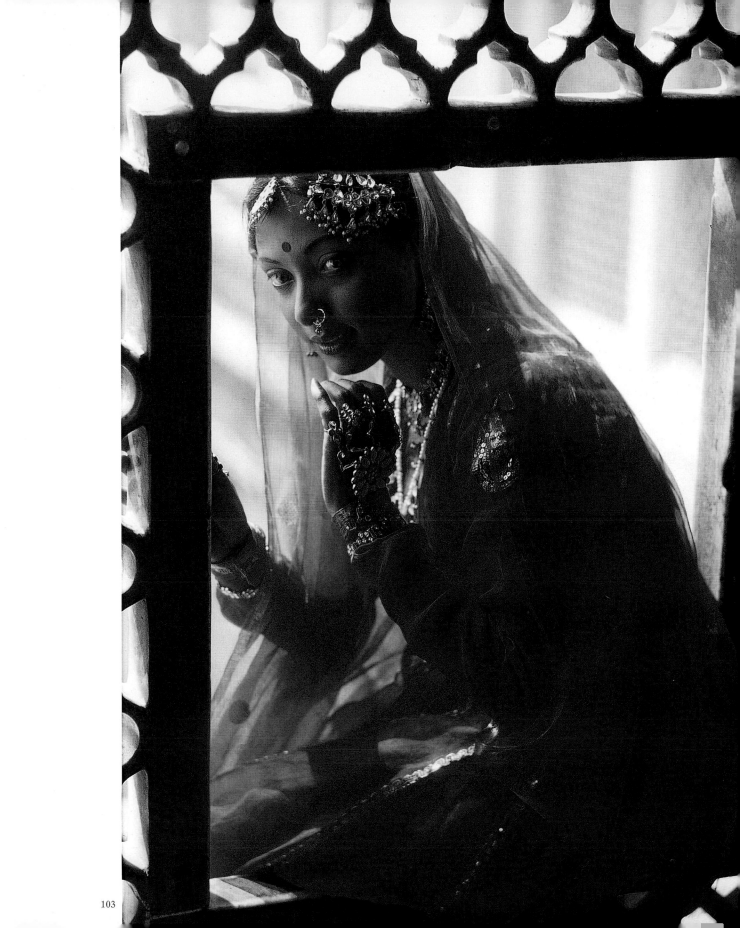

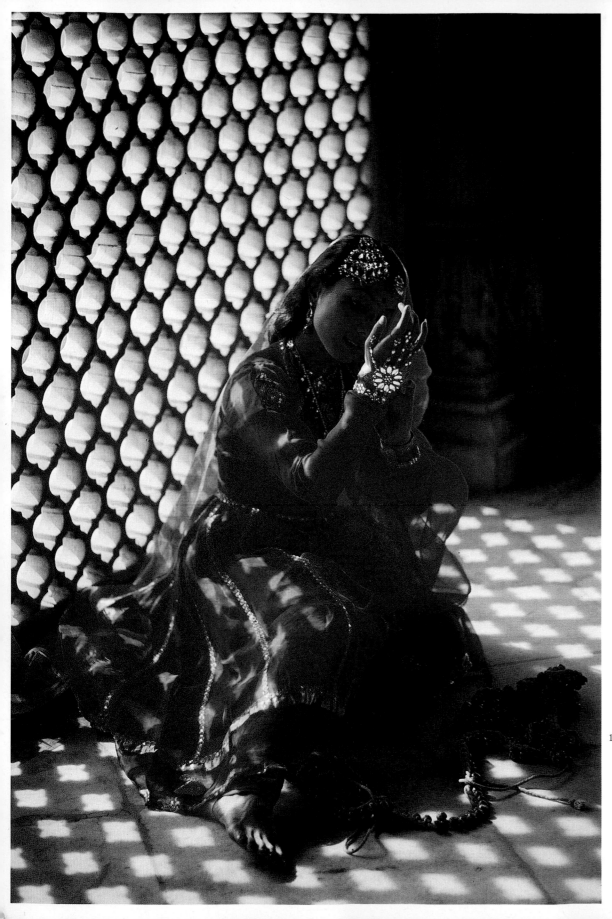

104

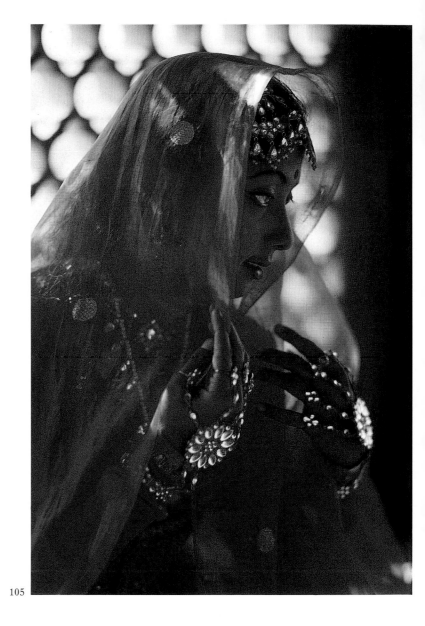

105

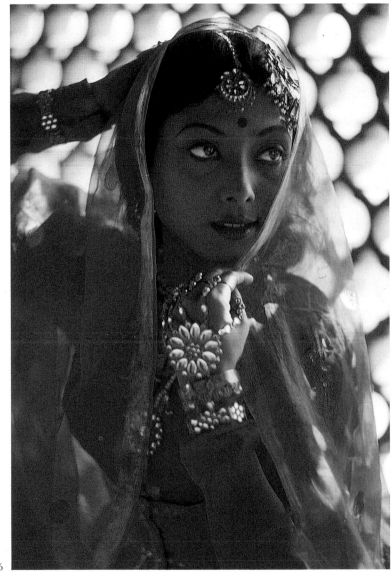

106

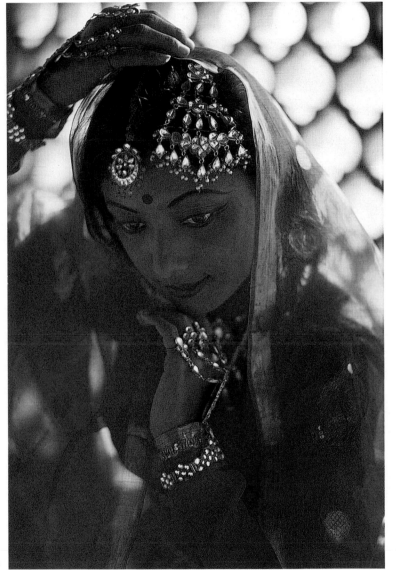

107

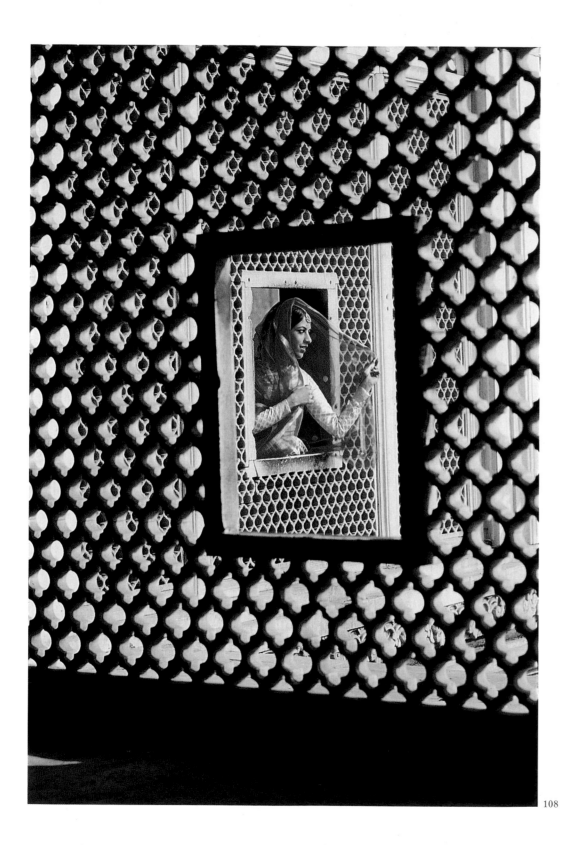

108

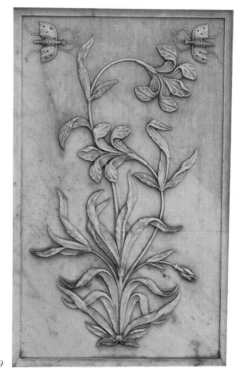

109

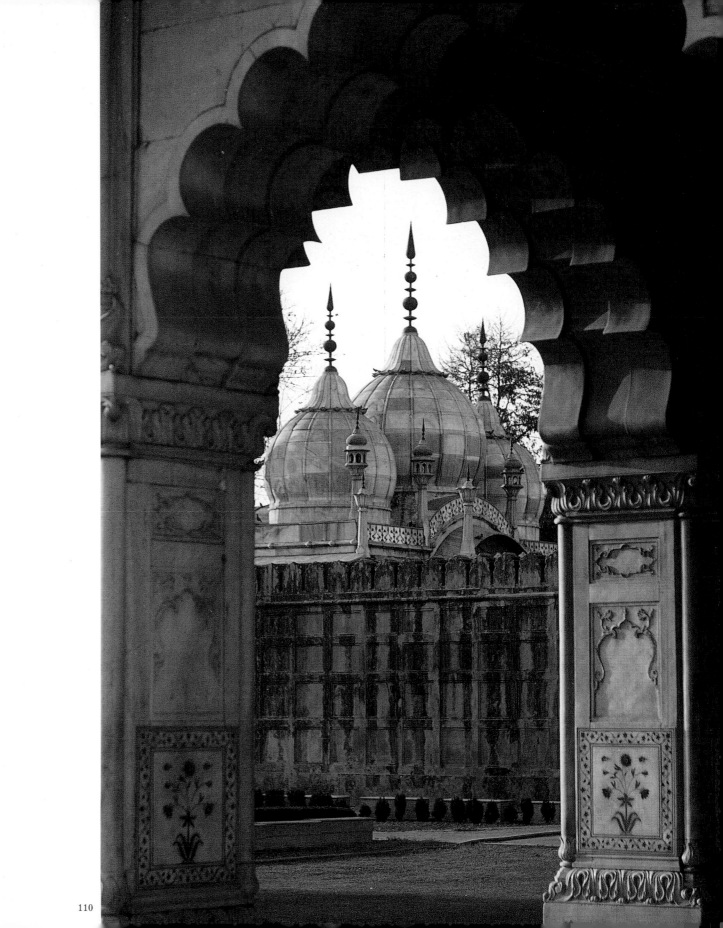

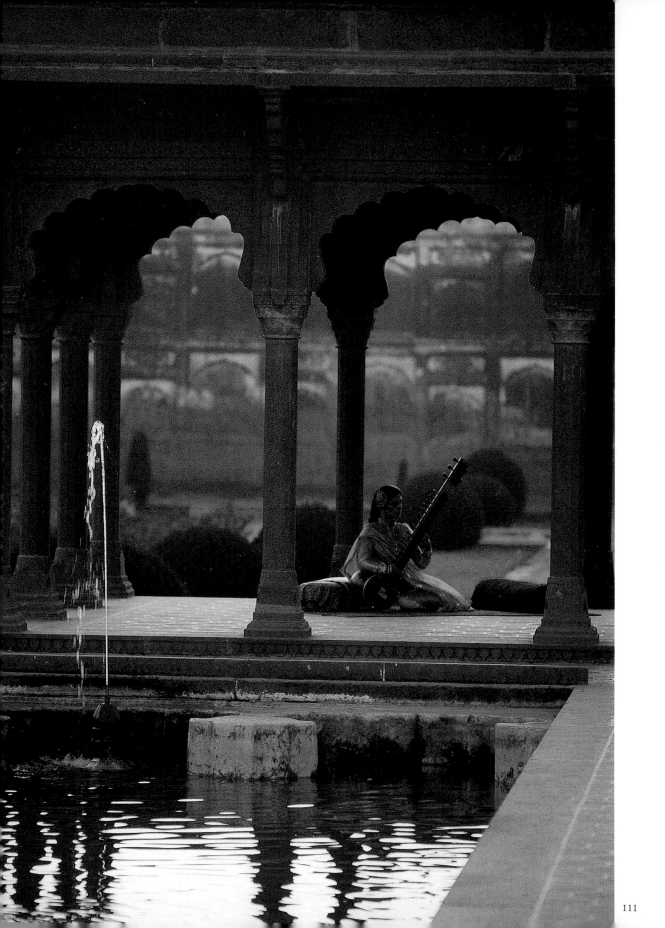

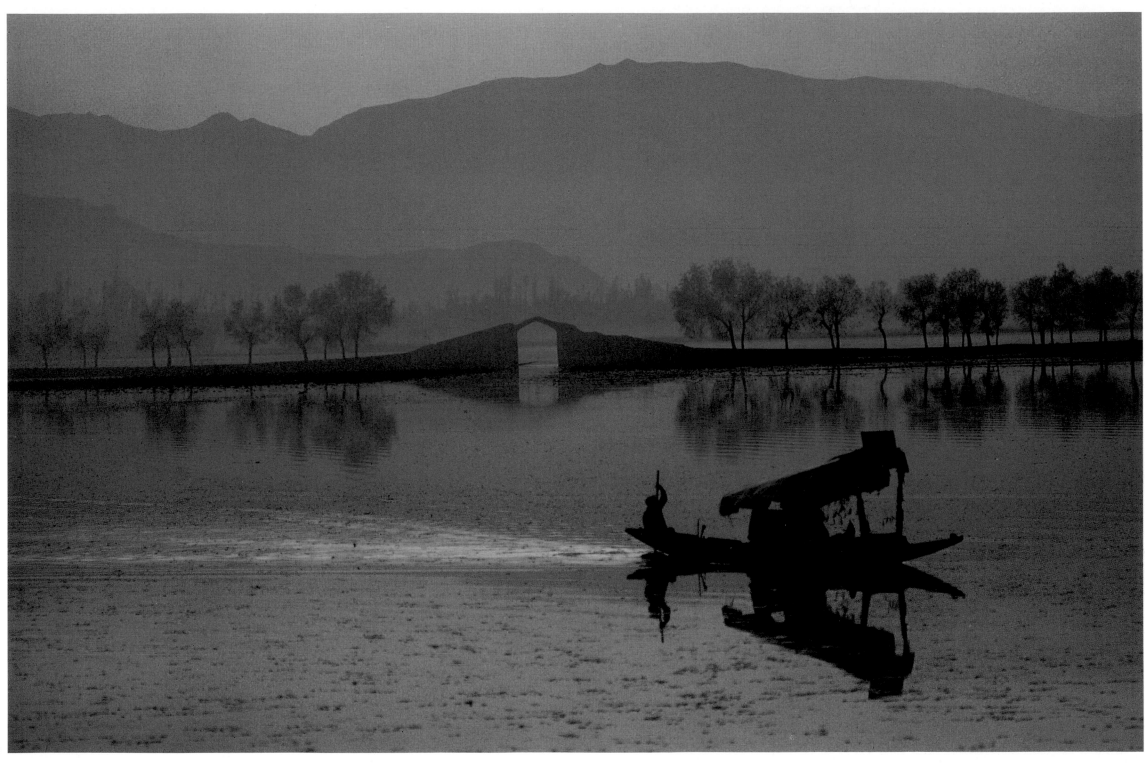

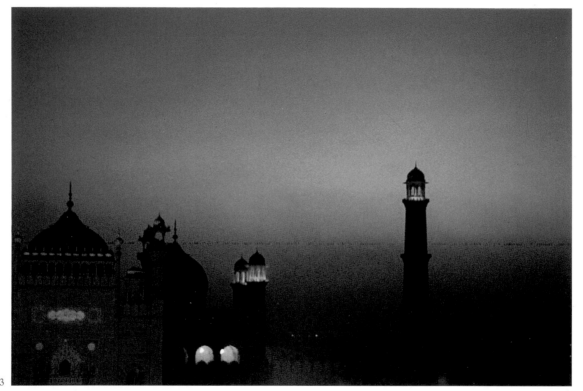

113

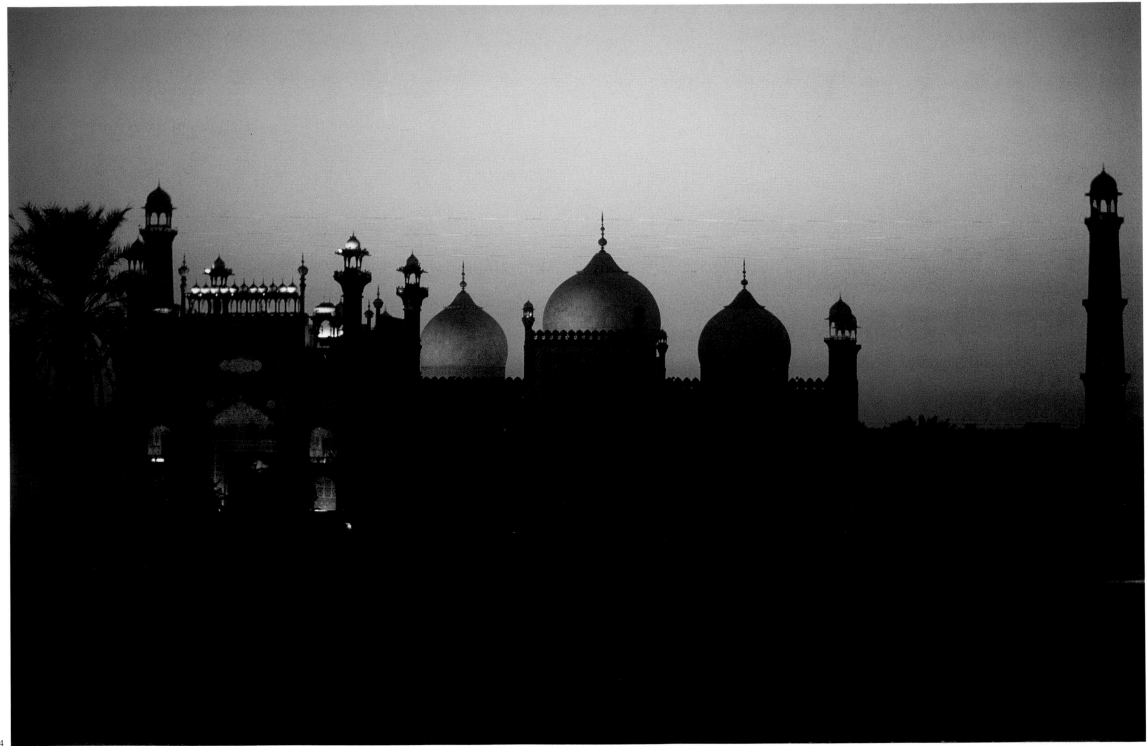

26–28: February 1966—Madras
Traditional expressions on the face of Padma, a young bharata natyam dancer.

29: April 1984—Udaipur, Rajasthan
At home with Lala, a sitar player.

30: February 1985—Samod, Rajasthan
Kalbelia dancer in the palace at Samod.

31: April 1984—Udaipur, Rajasthan
Reka, a Rajput girl of fourteen.

32: March 1966—Alleppey, Kerala
Beneath a canopy of palm fronds, "wallams"—the equivalent of China's sampans—ply the interior waterways.

33: October 1981—Rohri, Sind (Pakistan)
Portrait of a fisherman.

34: September 1981—Umarkot, Sind (Pakistan)
Falcon.

35, 36: February 1985—Samod, Rajasthan
Kalbelia dancers in the palace.

37, 38: November 1981—Pampur, Indian Kashmir
Saffron fields and saffron harvest.

39, 40: February 1985—Jodhpur, Rajasthan
A jeweler's window display in the old city. A woman trying on jewels.

41: September 1981—Umarkot, Sind (Pakistan)
Falconer and his falcon. The man wears the typical regional headgear.

42: December 1981—Agra, Uttar Pradesh
A pavilion on the banks of the Jumna, across from the Taj Mahal.

43, 44: February 1985—Samod, Rajasthan
Kalbelia dancers applying their makeup before a performance in the Hall of Mirrors in the palace.

45, 46: February 1985—Jaipur, Rajasthan
The Palace of the Winds, an architectural fantasy, is actually a façade honeycombed with nine hundred and fifty-three windows with perforated screens, allowing the women occupants to see out without being seen.

47: April 1984—Udaipur, Rajasthan
Rajasthani folk dancers.

48: November 1966—Pushkar, Rajasthan
A village woman with silver and ivory jewelry.

49: April 1984—Ajmer, Rajasthan
Dervish with cane.

50: February 1984—Peshawar, Pakistan
Copper stall in the old city.

51–54: November 1981 and November 1983—
Pushkar, Rajasthan
*Brief encounters. His name is Bahoulal, hers is
Shanti.*

55: February 1984—Lahore, Pakistan
Spice merchant at the bazaar in the city's old section.

56: December 1982—Peshawar, Pakistan
Portrait of a Pathan with henna-tinted beard.

57: April 1985—Udaipur, Rajasthan
Detail of a stained-glass window in the palace.

58: March 1985—Jodhpur, Rajasthan
Partial view of the city shot from the fort at dusk.

59: April 1968—Amritsar, Punjab
*Yogi of semiprecious stones encrusted in a marble
wall of the Golden Temple.*

60: April 1968—Amritsar, Punjab
Sikh merchant.

61, 62: April 1968—Amritsar, Punjab
*Details of semiprecious stone encrusted in the marble
walls of the Golden Temple.*

63: April 1968—Amritsar, Punjab
"Nihang" guards at the Golden Temple.

64: April 1985—Udaipur, Rajasthan
*The Lake Palace. Detail of a floral decoration
composed of small mirrors and colored glass.*

65: March 1985—Tilwara, Rajasthan
Portrait of a Rajput.

66, 67: November 1982—Jaipur, Rajasthan
The observatory's armillary spheres.

68, 69: September 1966—Udaipur, Rajasthan
The maharajah's elephants leaving the palace.

70: February 1982—Jaipur, Rajasthan
*Atop an elephant, a young man rides to his fiancée's
house.*

71: October 1981—Lahore, Pakistan
Fariha, a young Moslem bride of Rajput descent.

72, 73: February 1982—Jaipur, Rajasthan
*Princely guests at a society wedding. Plate 72 (left to
right): The father of the bride, the Maharajah of
Jodhpur and his son. Plate 73 (left to right): Dr.
Karan Singh, the groom, the Maharajah of Jodhpur
and his son.*

74: January 1965—Delhi
*Rajasthani folk dancing at an Independence Day
celebration.*

75: February 1978—Amritsar, Punjab
*The sixteenth-century Golden Temple, sacred
sanctuary of the Sikhs, is at the center of a pool
called the "Pond of Immortality."*

76: January 1984—Hyderabad, Andhra Pradesh
A young woman named Radhika.

77: January 1984—Hyderabad, Andhra Pradesh
A young woman named Sandhia with a yellow veil.

78: January 1984—Hyderabad, Andhra Pradesh
A perfumer's stand in the old city.

79: November 1983—Bikaner, Rajasthan
Detail of a stained-glass window in the fort.

80: April 1984—Ajmer, Rajasthan
Portrait of an antimony merchant. The product is used both as makeup and to protect the eyes.

81, 82: June 1966—Wular Lake, Indian Kashmir
Rice fields and local boats on the Wular, Kashmir's largest lake.

83, 84: April 1984—Udaipur, Rajasthan
Kamal and his sister Reka playing with their pigeon.

85: October 1982—Ahmadabad, Gujurat
Portrait of Aditi, a young Gujurati woman.

86: July 1982—Srinagar, Indian Kashmir
Lotus on Lake Dal.

87: November 1983—Ajmer, Rajasthan
Lake Anasagar at daybreak.

88: August 1977—Calcutta
Portrait of a bard.

89: April 1984—Agra, Uttar Pradesh
A geometric design of marble and red sandstone on the lower platform of the Taj Mahal.

90: April 1984—Agra, Uttar Pradesh
Flowers chiseled in marble at the Taj Mahal.

91: April 1971—Agra, Uttar Pradesh
Silhouette of the Taj Mahal at dawn.

92–96: 1971 to 1984—Agra, Uttar Pradesh
These pictures of the Taj Mahal show the marble's subtle variations in color at different times of day.

97, 98: 1971—Agra, Uttar Pradesh
The Taj Mahal on a foggy winter morning.

99: August 1982—Old Delhi
Door to the Great Mosque.

100: January 1984—Hyderabad, Andhra Pradesh
Moslem women in the old city.

101: Agra, Uttar Pradesh
The Taj Mahal across the Jumna, as a caravan of camels fords the river.